The Dancing Warrior Bride!

RELEASING A GENERATION OF PROPHETIC WORSHIP WARRIORS OF ALL AGES THROUGH THE ARTS!

KAREN S. LIGHTFOOT

authorHOUSE®

AuthorHouse™
1663 Liberty Drive
Bloomington, IN 47403
www.authorhouse.com
Phone: 1-800-839-8640

First published by AuthorHouse 9/28/2011

ISBN: 978-1-4567-5715-1 (sc)
ISBN: 978-1-4567-5716-8 (e)

Library of Congress Control Number: 2011908020

Printed in the United States of America

Any people depicted in stock imagery provided by Thinkstock are models, and such images are being used for illustrative purposes only. Certain stock imagery © Thinkstock.

This book is printed on acid-free paper.

Dedicated in Loving Memory of my Friend,
Sister in the Lord and devoted Armor Bearer
DAWNYA THOMAS
Who fought the good fight of faith to the very end...
You were a hero to all who knew you!

TABLE OF CONTENTS

ACKNOWLEDGMENTS

I WOULD LIKE TO START by saying thank you to the most important person in my life, my precious Abba Father, Jesus Christ and the Holy Spirit for saving me from myself and giving me wisdom, knowledge and the passion for others to write this book.

I extend endless thanks to my beloved husband, Ken, who has stood by me throughout 25 years of marriage and 21 years of ministry. You have been my biggest cheerleader and life coach! In the times I thought, *"I can't do this"* you were always there saying, *"You CAN do ALL things through Christ!"* Your unconditional love for me, and your passionate love for Jesus in my life is what has inspired me to love Jesus even more. I am honored to be your wife and can't wait to come into the fullness of what God has ordained for us. May we always continue to drink deeply of the River of God we love, and never stop dreaming together! From one River rat to another...I Love You...MWA!

I would like to honor my parents, Jerry and Arlene Rusk. I am so thankful for having parents that have stood by me through very difficult times of my life, demonstrating the unconditional love of Christ. Your beautiful examples of what a Godly mom, dad, marriage and being a Grandparent should look like, will forever be in my memory. I am thankful for all of the "life lessons" I've

learned and cherish the times of being raised in a home filled with joy, laughter and love. I love you both!

To my son, Troy: You have been my greatest treasure and think you're one of the most amazing people on earth! You have such a beautiful heart and have taught me many things throughout life. I love you and will always be proud of who you are.

To my daughter in love, Irena: We are so glad you are part of this family and thank God for bringing you to us. Thank you for the sacrifice you've made by leaving Australia to bring love and joy to Troy.

Deep thanks to my spiritual mom and battle general, Minister (Momma) Carolyn Johnson. I would not be where I am today if it wasn't for your love and encouragement to press in and become a battle-ax for the Kingdom of God! You have taught me so much through my spiritual boot camp training, but I will be forever grateful for the lessons you've taught me through intercession; one of the greatest weapons of warfare. The impartation of your radically, bold spirit and love for Jesus will remain in me for the rest of my life. This impartation continues to bring change and transformation to the body of Christ. You are truly an amazing woman of God!

Thank you to the men and women of God who have encouraged me and laid strong spiritual foundations in my life: Pastor Paul and Karen Jackson for laying a strong Word foundation, Pastor Bill and Mary Brendel for bringing out the hidden gift of the arts in me and teaching me how to be free in the Spirit, and Pastor Daniel McKenna for giving me a platform to bring down the Kingdom of Heaven here on earth through the arts. May the sweet presence of the Holy Spirit and blessings be bestowed upon all of your churches.

Special thanks to all my friends who have unconditionally loved, supported and prayed for me and the ministry: Chriss

Caffee, Jodi Ann Kochie, Pat and Bob Hrehowsik, Kay Jobes, Judi Chimienti, Bernadette Carter, Antonia Roman, Admirah Sefa, Beth Garcia, Karen Quinn, Carol Gentile, momma Lilly Daniels and Minister Crystal Niblack. Thank you, thank you, thank you...I love you all!

To my sister in Christ and friend, Belinda "Billie" Fontanez-Rivera, thank you for contributing your beautiful artistic gift of designing the artwork for my book cover.

Lastly, to my former dance ministry and spiritual children, *Movement with a Message*. There is not a day that goes by that I don't think about the great and awesome things God did through us as a team. Each face and name will forever be branded in my heart. You are all amazing and I know God will continue to do great exploits through you. Remember and continue in the things you were taught. To my leaders: Regina Arthur, Brianna Hayes, Bria Romano, Kimberly Ruff, Taylor Quinn and Kennedy Freeman: thank you for all your hard work and devotion to the Lord and ministry. So many times your love, support and commitment kept me steadfast as your leader. I am so proud of you and considered it a great honor to have "warred " together in the spirit. I deeply admire and have great respect for who you are as young women of God. WE WILL NEVER FORGET THAT WE ARE JUST DONKEYS CARRYING THE PRESENCE OF GOD...HEEHAW!!!!

INTRODUCTION

In October 1999, I attended my first prophetic worship gathering in a barn somewhere in NJ. Not really knowing what to expect, I can honestly say I was a little nervous about the whole thing. Before the meeting started I remembered seeing people walking around with bare feet, smiles on their faces, flags in their hands and an excitement like something really awesome was about to take place. I felt these people knew something I didn't; something really exciting was about to happen inside that barn. As I timidly stood in the back, the musicians started to play and I saw these people start to sing, dance, shout and wave flags everywhere. I thought they were crazy! They were singing love songs to Jesus like He was really there in that barn. It was in this place, a barn, that I would experience the presence of God like never before. It was apparent I was missing something; they had something I didn't and their passion to worship Jesus was like something I never saw before. So there, in the midst of a 70's time zone, I stood with my heart pounding experiencing something new; something that would change my life forever, the wonderful presence of the Holy Spirit. And it was there that I would experience my first prophetic word from the Lord.

After the service was over, they made an announcement to anyone who wanted a word from the Lord to come to the rooms in the back of the barn, to be prophesied over. I thought to myself, "whew, what else could possibly happen after all this?" I was about to find out. My friend Betsy and I went to the back

of the barn where there were three rooms with long lines of people waiting to go inside to hear a word from the Lord. Betsy was really excited about the whole thing, but I was feeling very uncomfortable, as it was new to me. When our turn finally arrived, I asked Betsy to come in the room with me, as I was feeling quite nervous, but she wanted me to get my feet wet in this thing called the River of God, or should I say, get thrown into the River! There were three rooms you could have been assigned to; Betsy went to room two and I was in room three. I wanted to enter those doors as much as a cat wanted a bath! I opened the door and saw to my left about eight people (prophets) sitting in chairs. They had one chair in the middle of the room; that is where I was to sit. As I started to walk toward the chair, a very tall young woman in her 20's quickly stood up and yelled, "What is your last name?" I came to a stand still, looked at her and sheepishly said, "Lightfoot". She pointed her long, boney finger at me and said, "That is a prophetic name, and God is going to call you to dance". I wanted to run out of there as quickly as I could. I thought these people were absolutely nuts! I thought to myself, "Why would God call me to dance for Him, when I had never danced in my life, except Hawaiian dance in high school? Wouldn't God only call those who have had formal dance training to dance before Him?" As these thoughts flashed through my mind, I quietly sat in my chair and received a few more words spoken over me, but the only one I can recall to this day is the word on dance. After they were done, I graciously bailed out of there with sweat on my brow! I met up with Betsy and we exchanged our words to one another, and as far as I was concerned, I was just going to leave and try to forget what I felt and saw. As the days progressed, the Holy Spirit wouldn't let me forget what was said to me. I couldn't help but remember how I felt, as unusual as it was I felt a pull, like that of a vacuum. Little did I know it was the Holy Spirit drawing and wooing me to pursue Him, like never before!

Two months went by and God had called my husband and I out of a church we loved, served and were mentored in for 11 years. As painful as it was to move on and say good-bye, God was placing our feet on a new journey; a journey that would change our lives forever, one that would lead me to the writing of this book. Within two months in our new church, the pastor approached me and asked me to minister in dance at the upcoming Easter play. It was a dance to be done before the altar call. In his church were trained ballet dancers, who I admired watching during worship. Their graceful movements and passion to worship Jesus was something I never seen before. I told the pastor that I never danced before, and that he had plenty of skilled dancers to do the job. The pastor simply smiled and said, "No, God told me to ask you. Be careful if you say no, because you're not saying no to me, but to Him." Well, what could I say to that! I loved the Lord and wanted to please Him in every way so I softly said ok, and walked away. After I had a moment to think about what I just agreed to do, I wanted to cry! There was no way I could get out there and do something I had never done before; I would make a fool of myself! Can you imagine the warfare in my head that went on? About three days later, the Holy Spirit brought recall about the prophecy of me dancing. I was so amazed how quickly God worked. It was at this point, that God would call both, my husband Ken and I, to the ministry of the arts. He played Jesus in the Passion of Christ drama and I ministered in dance at the altar call.

This book is about how to be trained, as an effective worship Warrior Bride in these last days through the fine arts. It doesn't matter whether you are currently involved in a dance ministry or maybe are feeling the call to start one, but inside these pages are effective keys to teach you how to build a powerful arts ministry or simply ignite a fire to the one you already have.

It is important to remember that satan operates his kingdom

by counterfeiting the true Kingdom of God. We can clearly see today, that satan has done a great job of doing this in regards to the arts. Unfortunately, without proper training, the church has grasped the world's view on dance, creating dances in the church, that look and sound just like the world. Some have even said they do it to "attract" the unsaved for evangelism purposes, but we cannot forget it is the power of the Holy Spirit (the anointing) that brings conviction for all to come to the saving knowledge of the Lord Jesus Christ. God will bless and anoint dances that are released from His heart to fulfill the Great Commission and to set captives free.

Let's set aside worldly mindsets, and usher in a heavenly shift in the spirit realm, to pull down dances from heaven to bring glory and honor to the Name of Jesus in all that we say and do. Whether you currently are in a dance ministry, or feel the call to start one, God longs for His people to passionately pursue His presence, to be filled with the Spirit and take the Kingdom of God by force! There is a great harvest that awaits us all, right outside our doors, souls that are desperate to know God, to experience God, and see the miraculous power of God demonstrated in this generation.

This is a training guide that will also transform your daily walk with God into deeper levels and encounters with the Holy Spirit. You will discover that in the ministry of dance, the "dance" is the last thing God really desires of you. He longs to first captivate your heart!

You will also discover the keys to the anointing and how to make your dance a lethal weapon against the kingdom of darkness! This book is not for the weak or the fainthearted, but for those who are willing to walk in extreme obedience to the General so that those around you can be forever changed by the power and presence of God that is in you.

By enlisting in God's army, rest assure, there will be great sacrifice and a price to pay for being on the front lines of ministry, but the rewards of being part of the Warrior Bride, far outweigh anything you will ever experience in your Christian walk. It will be fun and exciting, yet at the same time, you will be challenged, sharpened and placed in the Refiner's fire, coming out like pure gold. This is the Father's heart for you.

My prayer is that this book will create a deep hunger, and passion to pursue the presence of God, so you can experience the "secret things" of God in His Kingdom!

May the spirit of Joshua and David rise up in this hour; being strong and courageous, while releasing a radical praise that breaks the back of the enemy that destroys every yoke of bondage!

Arise Dancing Warrior Bride! Prepare for battle, and make yourself ready! Go forth in His mighty power to heal, save, deliver and set free the captives...this is your purpose; this is your calling. *Your destiny awaits you.*

Welcome to Spiritual Boot Camp!
"Preparing for War"

Therefore, prepare your minds for action...."
1 PETER 1:13

Believers (soldiers) must have an attitude of perseverance. They must accept the fact that suffering hardships and difficulties is part of warfare. They must be determined to go through it, no matter what. Basic training can be hard on new recruits, but the goal is to make them tough and hard yet possessing a heart of tender love.

"Endure hardship like a good soldier"
2 TIMOTHY 2:3

-Gwendolyn A. Cook

This book is designed for you to study along with your Bible for a deeper understanding.

If you are starting a dance ministry or wanting to raise the standard higher in your current one, the following should be established in your training sessions:

What to bring to Boot Camp each week:

1. Your Bible: It is your offensive weapon (Sword of the Spirit). Never leave home without it!
2. Notebook and pen (come equipped and ready to learn)
3. Loose-fitting clothes (you may want to establish a dress code. I had team t-shirts made with our dance ministry name on them.)
4. A mindset of excellence! (*Whatsoever a man thinketh in his heart, so is he.* PROVERBS 23:7)
5. A good attitude (Attitudes are contagious, *is yours worth catching?*) Come with a teachable spirit and be willing to change from your old ways to the new.
6. Be on time (We serve an on-time God!)

May the Lord bless your efforts as you move in to your next level and achieve a spirit of excellence for the King!

Creative Arts Policy and Procedures
"I urge you to live a life worthy of the calling you have received."
EPHESIANS 4:1 –

This segment is not intended to bring bondage to anyone through a set of rules, it is meant to raise the bar in your walk with God. Everything we do unto the Lord should first flow out of a heart of love for Him, then walk in obedience to His Word because of this love. (*"If you love me, you will obey what I command."* John 14:15) It is imperative that you walk together as a team in love, unity and order. For some, these guidelines may seem difficult or unreasonable to follow but please understand that this is an upfront, spiritual warfare ministry where there can be no place for the enemy to gain access in to your ministry. This type of ministry will require you to be self-controlled, applying the necessary spiritual disciplines that a soldier must possess in order to fulfill their call to duty. If you read these guidelines and begin to sense a feeling of not being able to achieve this

level of excellence, please know that this is a good sign, and that "This ministry is for YOU!" No matter what length of a time you have walked with God, please be reminded that we are all a spiritual "work in progress" until we see Jesus in glory but let's not make this an excuse for spiritual laziness and complacency. The Holy Spirit is always attempting to be at work in us, to sharpen and prune those ungodly areas of our lives. Give Him your permission to do this deep work; it will only lead you to Godliness. Jesus said in John 15:2 that any branch in Him that does not bear fruit is cut off, but those branches that do bear fruit the Father prunes. The pruning process can be a painful one but is mandatory for your spiritual growth. The fruit Jesus is referring to here is, the fruit of the Spirit (Galatians 5:22-23) and winning souls (The Great Commission Matthew 28: 18-20). When God begins to prune you, He may remove ungodly friendships, worldly mindsets, habits and even possibly Godly friendships, that may hold you back from going in to your next spiritual level. Not everyone, even God's people, will rejoice in your new spiritual elevation: mostly due to either jealousy or just not wanting to pay the price to get there for themselves so you can expect to endure some discomforts in your new journey. I have experienced all these things in my walk with God through the years and, all I can say is, it is so worth it! By practicing these spiritual disciplines, you are aligning your life with the Word of God; you will never go wrong walking down this pathway of life and you can be sure that blessings will follow. I would love to hear the wonderful testimonies of how these disciplines have changed and transformed your life!

A note to parents who have children in the ministry: We all love to see our little ones on stage ministering before the Lord, but please keep in mind that this is not the Al Alberts show. I do not mean this statement to be disrespectful in any way, but your leader will be responsible for placing your child in a warfare zone and may need to make some difficult decisions

as what part your child will be doing and their involvement. Please have faith in your leader that she hears from God and is being obedient to the leading of the Holy Spirit. There may be times when your child won't dance because of the intensity of warfare; the leader will be doing her job to cover and protect your child from attacks of the enemy. Please encourage, support and pray for your child's leader, as the warfare gets intense and unbelievable at times. *Be flexible, flexible, flexible!*

Adult/Child Guidelines for the Arts Team

The following are recommendations of laying a strong foundation for your dance ministry.

1. **Be a living example in your Christian walk by:**

 a. Demonstrating a life of self-control and goodness. (Titus 2:1-8 says; *[1]You, however, must teach what is appropriate to sound doctrine. [2]Teach the older men to be temperate, worthy of respect, self-controlled, and sound in faith, in love and in endurance. [3]Likewise, teach the older women to be reverent in the way they live, not to be slanderers or addicted to much wine, but to teach what is good. Then they can urge the younger women to love their husbands and children, [5]to be self-controlled and pure, to be busy at home, to be kind, and to be subject to their husbands, so that no one will malign the word of God. [6]Similarly, encourage the young men to be self-controlled. [7]In everything set them an example by doing what is good. In your teaching show integrity, seriousness [8]and soundness of speech that cannot be condemned, so that those who oppose you may be ashamed because they have nothing bad to say about us.)*

 Being in a highly visible ministry, people will automatically be watching the way we live our lives. God

4

instructs us in His Word to live a lifestyle that others can pattern their lives after. The apostle Paul said, *"follow me as I follow Christ."* (1 Corinthians 11:1)

b. Modest dress (1 Tim. 2:9 says, *I also want the women to dress modestly, with decency and propriety, adorning themselves, not with elaborate hairstyles or gold or pearls or expensive clothes.)* Dressing modestly simply means looking normal without drawing attention to ones self. Your physical body is a walking billboard for all to see. Take some time now to stop and search your heart and ask these questions: What is my billboard advertising and saying to those around me by the way I dress? Is what I am wearing bringing dignity and honor to God or drawing the wrong kind of attention to self? Is my billboard advertising from a worldly perspective or a Kingdom perspective? Would Jesus approve of how I am representing Him? After searching your heart, talk to the Holy Spirit and give Him permission to bring conviction to any area that may need to be changed. Repent and receive God's love of being washed and cleansed so you can walk in total freedom! This is not about legalism but about aligning our lives with the Word of God and who we are professing to be as Christians. As we grow and mature in our walk with God, every area of our lives needs to line up with His Word. This is the standard that we are to live by and not by what the world, magazines or media tells us.

c. Christ-like attitude (Philippians 2:1-7 says, *¹Therefore if you have any encouragement from being united with Christ, if any comfort from his love, if any common sharing in the Spirit, if any tenderness and compassion, ²then make my joy complete by being like-minded, having the same love, being one in spirit and of one mind. ³Do*

nothing out of selfish ambition or vain conceit. Rather, in humility value others above yourselves, ⁴ not looking to your own interests but each of you to the interests of the others. ⁵In your relationships with one another, have the same mindset as Christ Jesus ⁶Who, being in very nature God, did not consider equality with God something to be used to his own advantage; ⁷rather, he made himself nothing by taking the very nature of a servant, being made in human likeness.) The ministry of dance is about serving in the body of Christ; helping people get their break through, by delivering a visual message through movement and preparing an atmosphere for the pastor to bring forth the Word of God.

d. Relationships (Ephesians 4:32) being kind, compassionate, walking in forgiveness and love towards all men. Once again, because this is an up front ministry, people will be watching your walk with the Lord very carefully. We need to be willing to demonstrate love towards others, creating a true picture of the life of Christ at any cost. This will require dying daily to self. (1 Corinthians 15:31)

2. Be a member in good standing:

a. Attendance (Hebrews 10:25 says, *not giving up meeting together, as some are in the habit of doing, but encouraging one another—and all the more as you see the Day approaching.)* Be on time at worship services and treat gathering together with the body of believers better than your own job. Some people treat their earthly jobs with greater care and more concern than the House of God, this should not be.

b. Tithes and offerings (Luke 6:38 says, *Give, and it will be given to you. A good measure, pressed down, shaken*

together and running over, will be poured into your lap. For with the measure you use, it will be measured to you.) Tithing is an act of obedience, which commands a blessing to follow. Let's give with gladness and joy! (2 Corinthians 9:7 says, *Each of you should give what you have decided in your heart to give, not reluctantly or under compulsion, for God loves a cheerful giver.*)

c. Guard from just being connected with your own ministry and support other ministries within the church. For example, if the church is having a clean up day, bring the entire dance ministry team to come and participate in it. Serving in different areas of the church was actually a requirement for my team to be able to minister in dance at the altars. This helps the team stay connected to others in the body of Christ and teaches them that serving back behind the scenes is just as important to God as dancing in the front of the church. We should never be above scrubbing toilets; it keeps us humble!

3. **Report to practices and rehearsals on time.** If you are running late, please notify the Arts Instructor on their cell phone. If your practice time is 7:00pm, be there before that time ready to go. Once again we serve an on-time God.

4. **Wear proper loose-fitting dress attire for practices.** I recommend wearing t-shirts that cover shoulders and waistline. Please wear appropriate dance shoes in class (no flip flops or slippers). Black or white dance palazzos and getting dance team t-shirts are also recommended. Please keep fashion statements outside of your ministry.

5. **Partake of all consecrations and fasts** as instructed by dance leader and Pastoral leadership (Matthew 6:16-18 says, [16]*"When you fast, do not look somber as the hypocrites do, for they disfigure their faces to show others they are fasting.*

Truly I tell you, they have received their reward in full. [17]But when you fast, put oil on your head and wash your face, [18]so that it will not be obvious to others that you are fasting, but only to your Father, who is unseen; and your Father, who sees what is done in secret, will reward you.) On the week of ministering, fast at least one meal per day, but not on the day of ministering. (Please see Chapter 4 on practical ways to prepare for ministry.)

6. **Acknowledge that you will play an important part in someone's Christian walk** (Philippians 4:9 says, *Whatever you have learned or received or heard from me, or seen in me—put it into practice. And the God of peace will be with you.)* God has placed specific gifts in each one of us. Discover your gifts, function in them and be a good steward of it. A few examples of this are: if you can draw and are creative, make a picture or logo to have printed on your team t-shirts. If you are administrative, offer to help take care of ordering the dresses, or do any type of computer work for the leader. If you have the gift of hospitality and helps, offer to be in charge of any fundraising activities and help with kitchen responsibilities, etc. By offering your gift to your leader, it will take a tremendous load off of her so she can stay focused on her gifting as teacher/leader.

7. **Be willing to accept constructive correction** (2 Timothy 4:2 says, *Preach the word; be prepared in season and out of season; correct, rebuke and encourage—with great patience and careful instruction.)* This is very important to be teachable at all times. Your leader will be able to see things you may not. Trust God that your leader will bring in any necessary correction in a loving manner. She is called to raise the standard in your walk with Christ, to get you into your next spiritual level.

8. **Keep the temple of God healthy** through good nutritional

habits, exercise, and abstaining from drugs, use of excessive alcohol and tobacco. (1 Corinthians 6:19-20 says, *¹⁹Do you not know that your bodies are temples of the Holy Spirit, who is in you, whom you have received from God? You are not your own; ²⁰you were bought at a price. Therefore honor God with your bodies.*) If you are currently struggling with any addiction, please advise your leader so you can get prayer to have the stronghold broken off. In most cases, I have seen those who struggle with addictions get their break through as they worship the Lord freely in the dance. (Please see Chapter 8 for more information on nutrition.)

9. **Have a desire to separate oneself from the patterns of this world** (Romans 12:1-2 says, *¹Therefore, I urge you, brothers and sisters, in view of God's mercy, to offer your bodies as a living sacrifice, holy and pleasing to God—this is your true and proper worship. ²Do not conform to the pattern of this world, but be transformed by the renewing of your mind. Then you will be able to test and approve what God's will is—his good, pleasing and perfect will.)* Our carnal minds need to be renewed daily in order to walk in the Spirit. We cannot stay in our carnality and must make daily, willful decisions to be renewed in our thinking that affects our lifestyles and the way we live.

a. Ungodly/secular music (Psalms 141:3-4 says, *³Set a guard over my mouth, LORD; keep watch over the door of my lips. ⁴Do not let my heart be drawn to what is evil so that I take part in wicked deeds long with those who are evildoers; do not let me eat their delicacies.*) **Sorry to say but garbage in, garbage out!** You will reap nothing constructive for your spiritual walk with God by listening to secular music. You simply feed the flesh, (the ways of your old nature) which needs to be crucified on a daily basis in order to bear good fruit. The will of the

Father is for us to produce good fruit, and to continually grow into maturity. If you struggle with getting rid of your secular music, a stronghold has taken place in your life and needs to be broken. Anything that you can't "do/live without" has become an idol and stronghold in your life. It must be broken off and be replaced with the things of God.

b. Gossip, perverse speech and slander (Titus 3:1-2, Ephesians 4:29-31, 5:4); these scriptures are very serious warnings to rid ourselves of such things in our lives. They will only destroy your relationship with God and with others. Blessings, not cursing, should proceed out of your mouth. (Romans 12:14 says, *Bless those who persecute you; bless and do not curse.)*

c. Sexual immorality/fornication/adultery (Ephesians 5: 3, 5-11, I Corinthians 5:9-11, 6:9-11); Please take the time to read very carefully these scriptures on this subject. We cannot be at the altars of church worshipping a Holy God, and go home to our perverted lifestyles and believe He will bless our circumstances. If you are thinking in this way, it is not aligned with the Word of Truth. (I Corinthians 6:9-11 says, *⁹Or do you not know that wrongdoers will not inherit the kingdom of God? Do not be deceived: Neither the sexually immoral nor idolaters nor adulterers nor men who have sex with men, ¹⁰nor thieves nor the greedy nor drunkards nor slanderers nor swindlers will inherit the kingdom of God. ¹¹And that is what some of you were. But you were washed, you were sanctified, you were justified in the name of the Lord Jesus Christ and by the Spirit of our God.)* The Word of God clearly teaches us not to live this way, and is such a serious matter, that God says it can even cost us our place in heaven if we do not repent. (1 Corinthians 6:9-

11). There are no earthly pleasures or lifestyles that is worth forfeiting heaven. True Christians will desire to align their lives and walk in total obedience to the Word of God. If this is an area that you are currently struggling with, God has provided a way out through His grace and mercy. Make a decision today to repent, receive forgiveness and walk freely with no condemnation. The blessings and anointing of God is waiting there for you to receive. You may want to have an accountability partner to help keep you on the right track.

d. Witchcraft/the occult (Deuteronomy 18:10-13 says, *[10]Let no one be found among you who sacrifices their son or daughter in the fire, who practices divination or sorcery, interprets omens, engages in witchcraft, [11] or casts spells, or who is a medium or spiritist or who consults the dead. [12]Anyone who does these things is detestable to the LORD; because of these same detestable practices the LORD your God will drive out those nations before you. [13]You must be blameless before the LORD your God.)* Witchcraft is another area in which Christians walk in deception. The use of ouija boards, reading horoscopes, palm reading etc. opens doors for the enemy to come into our lives and operate. Many who do these things, do it out of ignorance to the Word of God. *"My people perish for the lack of knowledge."* (Hosea 4:6) Be alert to the traps of the enemy and do not even entertain the thought of being involved in them.

10. For the Youth: If you are not at the age for marriage, you must refrain from being alone with the opposite sex if dating. Stay in groups and pursue an accountability partner along with abstinence. God has established dating for you to find a husband or wife. You would be wise to stay in groups with friends and never be alone with the opposite sex

to put yourself in a position where sexual immorality can happen. The temptation can be too strong and you may be led in to doing things that would not honor God. Abstinence, abstinence, abstinence! We cannot conform to the patterns, pressures, and the messages of this world. Go against the flow and be different! Deep inside, people will respect and admire you even if they make fun of you because you have made a decision to stay a virgin. You will never have to worry about early pregnancy, STD's and date rape that is so common these days. God will honor and bless your covenant of purity! There is grace and mercy waiting at the doorstep of your heart, so if this is an area you have fallen short, pray this prayer: *Father, I ask you in the Name of Jesus, to forgive me from sexual immorality and impurity. I repent, renounce and break off any soul ties that have attached themselves to my life and apply the powerful blood of Jesus for the washing and cleansing work within me. Send forth the power of the Holy Spirit so I may walk in complete newness and holiness all the days of my life. I want to align my life to Your Word so I can bring glory and honor to Your Name. Thank You for forgiving me and healing any woundedness from my past and former life in Christ. I praise You that I am a new creation in Christ, the old is gone and the new has come!* ***Amen!*** (Please refer back to 9c for sexually immorality scriptures).

11. **Anyone speaking against leadership/team member in a negative manner** (to tear down or destroy one's character) or exhibiting an unwillingness to follow leadership will be reported to Pastoral staff to handle. If you have a grievance, please direct them to your leader to settle matters quickly so that satan gets no foothold in the ministry.

12. **To the Parents:** I highly recommend that you participate, along with your child, in these training sessions for a deeper

understanding of the ministry of dance. If your child is absent from a class, it will be your responsibility to make sure any homework assignments missed during that training session is completed and turned in on time.

By signing this document of agreement, I understand and take my part in this ministry seriously. I understand that if I or my child chooses not to follow these guidelines, he/she will be asked to step down from his/her position until further notice.

Parent: _____ Date:_____

Student: _____ Date: _____

PLEASE PHOTO COPY THIS PAGE AND
RETURN TO YOUR LEADER.

Building Unity
... until we all reach unity in the faith and in the knowledge of the Son of God and become mature, attaining to the whole measure of the fullness of Christ.
EPHESIANS 4:13

1. Accepting Salvation
In order to minister effectively in dance or any of the arts, you must have accepted Jesus Christ as your Lord and Savior. My prayer is that if there is anyone who does not "personally" know Him. that they would receive Him as Lord of their life and come to a complete understanding of who they will be dancing for. Salvation brings a common bond between one another on the dance ministry team; it is important to be in one accord and move together as one unit, not leaving any soldier behind.

2. Getting to Know Me
Please complete the questionnaire below *about the person YOU see in the mirror.* If you have a large ministry, break into small

groups of four or five and discuss your answers. For smaller dance ministries, sit in a circle and share your answers. Please be transparent with each other and after you have completed the session, have the team get with a partner and pray for each other, thanking God for their strengths and asking the Lord to strengthen their weaknesses.

Mirror, Mirror on the Wall
Do you know who that person is in your mirror?
(Your answers do not have to pertain to dance. Some answers could be; I like chocolate, I dislike the winter months etc)

What are your likes and dislikes?

What areas are your weakest?

What are your strong points?

What are your short-term goals (this year)?

What are your long-term goals (next five years)?

How do you plan to achieve them?

Goals and Objectives
Without a vision, the people perish.
PROVERBS 29:18

Complete the form about your goals. A goal is: something you want enough that you're motivated to work relentlessly towards getting it. With goals, your thought should be: I'm going to make this happen no matter what!

Set 5 goals for this year in the Dance Ministry:

1 _____

2 _____

3 _____

4 _____

5 _____

Set 5 goals for this year in your personal life:

1 _____

2 _____

3 _____

4 _____

5 _____

Most importantly, remember:
All things are possible through Jesus Christ
(MATTHEW 19:26)

Don't let fear paralyze you.
God has not given us the spirit of fear
but power, love and a sound mind
(2 TIMOTHY 1:7).

PLEASE PHOTO COPY THIS PAGE
AND RETURN TO YOUR LEADER.

CHAPTER 2

Introduction To Dance:
Understanding your Call to Duty

To truly be an effective witness in the dance one must first come to understand what God is calling them to. The ministry of dance is a priestly ministry and needs to be respected as one.

What is Ministry?
Also I heard the voice of the Lord saying: "Whom shall I send and who will go for Us?" Then I said, "Here am I! send me."
ISAIAH 6:8

IT IS THE ANSWERING TO THE CALL ON YOUR LIFE!

1. Ministry recognizes a need and has empowerment and ability to fulfill it; you must be able to see the lost, sick and brokenhearted around you and be driven by compassion to bring healing through your dance. You must also have the physical capability and ability to fulfill the call. This does not mean you have to have professional, worldly training or technique but you will need some form of rhythm.

2. Ministry makes God's desires known to all; through your

movement, you are releasing a message to others from the Father's heart to those around you. You are used as a prophetic intercessor.

3. Ministry should flow prophetically (led by the Spirit of God); to do this, you must have an ear to hear what the Spirit of God is saying and an eye to see what He wants to have take place. Please see chapter three for more insight on prophetic dance and worship.

4. Ministry should focus on equipping the saints to make them ready for battle; your ministry should have a vision and mission statement; God will use this, as a bulls eye, to shoot for to obtain accuracy and focus in your ministry. There should also be a season of teaching and training before going out to the front lines of battle. It took 7 months before we ever danced our first dance in my first dance ministry. By doing this, it weeds out the people who just want to dance and be seen, from those who are really called to the ministry. Children may not understand at a young age the calling aspect of the ministry, so the leader will need to handle them differently than the teens and adults. *This training season is imperative to the success and final outcome of your ministry.* For example, look at these training sessions like the different stages of a pregnancy.

The conception period: Because of your desire to worship, your spirit came in to agreement with the Holy Spirit who deposited a deep desire to worship God in Spirit and in truth.

The gestation period: The first few months are the most critical for the healthy development of your new baby. If not fed the proper nutrients the baby could develop abnormalities, complications can set in and the pregnancy terminated. I call this a spirit of abortion. This can only happen if you are

not willing to take a short season to become skilled in the Word, and have the mindset of "Hey, let's just start a dance ministry" and in 2 weeks you're upfront bringing forth movement. I cannot stress enough that during this period, releasing the Word of God to bring forth knowledge and understanding to your ministry is crucial. The Word brings revelation and sets a secure foundation to be built upon. This foundation cannot be shaken or crumble because it is built on Christ the solid rock, the Chief Cornerstone.

Also, think of your ministry as taking a season of your life to pursue a career; let's say as a doctor. Before one can get a degree and practice medicine, there is an intense season of studying and training involved. Just think what it would be like if the American Medical Association would allow anyone who had the desire to become a doctor, to automatically start a practice and treat patients within 2 weeks! How much more should we, the people of God, flow in excellence in our ministries. There is a standard that has been set in the church today that is drastically lower than worldly standards when it comes to serving God. I am not sure why this is, but God is bringing a major shift for the equipping of the saints to the present day church to all who will embrace it. God does not desire for His sheep to be passive and dumb but to be transformed in to mighty warhorses! (Zechariah 10:3 says, *"My anger burns against your shepherds, and I will punish these leaders. For the LORD of Heaven's Armies has arrived to look after Judah, his flock. He will make them strong and glorious, like a proud warhorse in battle.*) That is what this book is all about; growing and maturing in our faith, giftings and callings so we can operate in a spirit of excellence that He so deserves. Let's raise the standard in our ministries so we can send a clear picture to the world that we are a reflection of an excellent God!

Finally, the birthing process: During this process you will sense an anxiousness to bring forth this baby because of the labor pains and contractions (pain that is usually involved in ministry), but wait on the timing of the Lord. You will know when the baby is ready to be pushed out by the unity, love and oneness of the team. It is then the "Dancing Warrior Bride" will come forth in power!

5. Ministry communicates the purposes of God for the generation; your dances will need to give a clear picture of what God is saying to the people. We need to have effective communication in our movement. If our movement doesn't match the words being sung it can actually lead to a spirit of confusion, therefore, your movements should be clear and precise.

6. Ministry is quality time spent with God and His Word; it is imperative to know who you are dancing for; first to Jesus then to His people. In John 15:5 Jesus said apart from Him, we can do nothing. This is a serious warning from operating in the flesh. We need to know the Word in order to dance the Word and are responsible to bring the Word of God to life through our dances. Just as a pastor preaches the Word by mouth, we preach the Word through the words of music and our movements. Most people unfortunately forget what they hear, but they won't forget what they see. This is the power of the arts!

7. Desires that the ministry be Spirit (God's) to spirit (congregation). Without the anointing of God, nothing gets accomplished and simply becomes a show or performance to those who are watching. You may wow the hearts of the people with your gift, but true Christian arts should always be directed to wow the heart of the Father.

THE CALL TO ANY MINISTRY IS A CALL TO LOVE,

VISION, FLEXIBILITY, COMMITMENT, SACRIFICE, HARD WORK, CLARITY AND FOCUS. THE CALL TO DANCE MINISTRY IS TO BE AN "ATMOSPHERE CHANGER!"

Your praise and worship should bring a shift in to the atmosphere of the congregation. Your calling in the ministry must always usher in a spirit of praise and worship where Jesus is the center of attention and the main focus. We must learn to worship Him in Spirit and in truth!

Throughout this chapter we will be taking some brief moments to do some prophetic self-examination exercises to help bring correction and alignment to any wrong motives and intentions of our hearts. Allow the Holy Spirit to do any necessary "surgery" so you can walk in total freedom.

What is a Minister?

A minister is a person who hears, and responds to the call of God on their life, and is a servant of God that communicates God's word to others. We must have a servant's mentality and a heart that desires to bring forth a clear message from heaven. Even though you may think you are here to dance, you are here to minister to the needs of the people. Philippians 2: 5-9 teaches us that we should imitate Christ's humility by our attitudes, allowing God to take our empty vessels and be filled with His glory, so we can be used for works of service. Verse 9 then tells us that God will exalt us to high places; this is your next level in the spirit God longs to bring you in to. The more we die to self the greater the power.

Spiritual Requirements for the Dancer

As we prepare ourselves to approach the altars of God in the ministry of dance, our first calling should be sincere devotion to Jesus, our first love. This calling places a deep desire in us that will enable us to draw close to Him with a yearning to seek Him with all our hearts. Our ministry will then be a result of the overflow of having spent time with Him. Only then can we truly answer the call to ministry for there are no substitutes or shortcuts for achieving the anointing.

After we have spent time in His presence, God calls us to worship Him in Spirit and in truth (John 4:24-25). The scriptures tell us that God is seeking worshippers not dancers. Although ability is necessary, God's Word does not exhort us to "praise Him in the dance" only if you have been to ballet, tap or jazz classes. The goal of the dancer's heart should always be fully committed to touch and please the Father's heart, desiring only to give Him all the glory.

SELF EXAMINATION EXERCISE: Take a moment and ask the Holy Spirit to reveal to you why you want to dance. Ask: what is my motive? Thank the Holy Spirit for revealing to you what is truly in your heart and repent, if necessary, of any selfish motives or intentions. Give Him permission from this moment forth to bring correction to you if the motives of your heart do not please Him.

Because there are no scriptural references that tell us to "sit and watch while others dance," our dance must truly be a priestly ministry, bringing Christ to the people, and/or the people to Christ. We are never to be the focal point. Because dance is such an upfront visible ministry, it is imperative for us to "hide ourselves behind the cross" and walk in holiness with a mantle of humility on our backs. We are called to be holy, because He is holy (1 Peter 1:16). Holiness is simply making the choice to be

separated from worldly habits, patterns and lifestyles and live totally consecrated unto the Lord. This is a life long process, but to truly be a child of God, we are commanded to live a life of holiness which is a prerequisite for entering the Kingdom of Heaven. (Hebrews 12:14 says, *Make every effort to live in peace with everyone and to be holy; without holiness no one will see the Lord.*) Some people may not walk in holiness before the Lord because they fear man more than God. They are so bound up in worrying about what their friends, family and co-workers think of them more than pleasing the Lord. Walking in *"fear of man"* is a serious stumbling block and stronghold that needs to be broken off by the power of the Holy Spirit. (Proverbs 29:25 says, *Fear of man will prove to be a snare, but whoever trusts in the LORD is kept safe.*) We are to fear God and God alone. (Deut. 6:13-15, Luke 12:5)

SELF EXAMINATION EXERCISE: Take a moment right now to examine this area of your life: Give the Holy Spirit permission to reveal any hidden truths of why you may be walking in the fear of man: Is it for popularity or security? Is my identity wrapped up in what others think or feel about me rather than trusting in what God's Word says about me? If God chooses to prune any relationship from my life where I am trusting man over Him because of security or self esteem issues, ask yourself now, am I willing to trust God and let them go? When I worship the Lord, do I worship in total abandonment or do I let those standing around me hinder my worship because of what they might think? Am I not doing something for the Kingdom of God because of my "image" and what others may say about me? Search your heart and repent if necessary. Release your fear of man to God and allow Him to take it from you. See yourself being totally set free from these chains and walk in liberty with a healthy fear of the Lord. Situations will arise, where you will have to make a conscious decision who you will fear, man or God. Every time you choose to fear the Lord, it will get easier

and easier, to gain victory in every area of your life. Your flesh will be at war and want to go back to the old ways but call on the power of the Holy Spirit and He will help you overcome. This is one way we can "train ourselves to be godly"(1 Timothy 4:8) and become the victorious Warrior Bride!

God is looking for people who desire to sit at His feet, commune and enjoy His presence. (2 Corinthians 13:14 says, *May the grace of the Lord Jesus Christ, and the love of God, and the fellowship of the Holy Spirit be with you all.)* Our Bridegroom's heart longs for an intimate relationship with His Bride connecting spirit to Spirit. Let us spend time with God until our dances come from Him. As we sup and commune with Him, the Spirit will pour dances "into" the dancer that will bring change to the lives of others. Therefore, we need to learn how to be sensitive to the Spirit's prompting as we visually demonstrate movements from heaven and empty our own (fleshly) dances to make room for His. Let's express the truths of God's heart to those around us.

As we minister as movement artists, we will need to become transparent in our worship. We must first possess a broken and contrite spirit before we worship in our movements, so we can begin to learn true expression. We need to be real and authentic when ministering, as people are able to spot someone who is a phony, or someone who "needs" to be seen for attention. Dear Warriors, let us press in until a spirit of humility and brokenness is established in us so the anointed dancer can be used by God to break off every yoke of bondage that keeps the people of God bound. The anointing is not only for your gift, but for your everyday life.

Ministry must come from the overflow. What I mean by this is, in order to give out something from within yourself, you must first have deposited or put something in. Much like a bank account. In order to withdraw funds, you must first have had to deposit the funds. Some Christians try to give out something

they don't have; they operate in the flesh, but God stamps on their work "insufficient funds." We are able to make daily deposits by praying, worshipping, reading the Word, praying in the Spirit, soaking etc. (Please see Chapter 3 on soaking). These are spiritual disciplines that prepare us to be over comers when the battles of life come our way. Let's work on making big deposits in our lives, so we can be a blessing to others in a big way!

Worshippers who possess a fiery passion for Jesus will win the end time harvest. The ultimate in our worship is not the expression of the worship – it is the knowledge of knowing who He is. The ability to excel in expression is not necessarily an indicator that someone is "anointed" by God. Only He knows the heart of the worshipper. Our responsibility is to make sure we are a clean, empty vessel so Christ's presence can be poured into us, and rest upon us. To truly be a useful tool in God's mighty right hand, make it a priority to daily seek His face. You may need to arise earlier than normal, but God will honor every step forward you take to be with Him.

Allow the Holy Spirit to challenge you to rise up at 4 or 5am just to seek His face. You will really get God's attention by letting Him know you are serious about going to your next level in the Spirit. If we keep doing the same old things, we will reap the same old results, so go ahead and take the challenge of doing something really different and radical in this season and watch what happens…*It will totally change your life!*

Definition of Spiritual Dance:
Bringing the Gospel to Life

So the Word became human and made his home among us.
JOHN 1:14 (NLT)

As I ponder this scripture that the God of this universe, Jesus

Christ himself, appeared in human flesh so that He could make my heart His home, I immediately feel overwhelmed by this truth! I can't begin to comprehend this to say the least but I am determined, and willing to do whatever it takes, to always make Him feel welcomed and right at home. He is not treated as a casual guest or visitor, as they come and go, but as a King who comes and takes up a permanent residence in my heart. My prayer is that this King is made to feel welcomed and comfortable in your home as well. May our beautifully designed welcome mats outside our hearts door read, "Welcome Holy Spirit!"

PROPHETIC ACTIVATION EXERCISE: This exercise is designed to bring you in to a place of cleansing, healing and acknowledgment of the realness of the presence of God in your life. As you are about to travel through 3 different rooms of your soul, trust that the person of the Holy Spirit will gently guide you in to all truth. After each room you will be given an opportunity to dig deep within your heart so the work of the Holy Spirit can bring light to any hidden, dark areas of sin. He loves you and longs for you to experience Him in a deep, special way! Please take your time during this activation exercise and try not to rush through it. This moment is just between you and your Father.

I want you to imagine for just a moment, that Jesus is standing and knocking at the front door of your home, ready to come and move in with you. You welcome Him in and begin to show Him His new home. You start with your living room (living room represents your soul; everyday emotions and decisions): *What does Jesus see?* Does He see a clean living room, prepared and presentable for a King to live in? Is it neat and in order where an atmosphere for a King can be made to feel comfortable? Perhaps you and Jesus have a seat and start to engage in wonderful conversation together, and suddenly you see His face begin to

change looking a bit uncomfortable, due to a major distraction being released in the atmosphere of your living room. At first you're not quite sure why this is happening as everything seems perfectly, everyday "normal" to you but then you see the eyes of Jesus kindly look over at the television where loud, mixed messages from the media and entertainment world, is overpowering your precious conversation together. Jesus longs for you to shut it all off, so He can just sit and spend precious time together with you.

Is it possible in your living room, that there are things lying around and out of order? Is there dust, indicating there has been a long period of time gone by that you have not cleaned this room? If so, do you make an excuse to Jesus why you haven't taken the time to clean?

Let's re-examine this room together with the Holy Spirit: If the daily decisions that you are making are lining up with the Word of God, begin to praise and thank God right now that your eyes have been enlightened to the truth and to the Holy Spirit's work of obedience in your life. Ask the Holy Spirit to continue to finish this work in progress to your final day here on earth. If there are areas in your daily decision making that you have not surrendered fully to the Lordship of Christ, which causes you to walk in disobedience, repent and pray this prayer: Lord, I am asking you right now to help me surrender every kingdom of my heart to Jesus. I ask you Lord to forgive me of any laziness, time that is unbalanced between the world and the Kingdom of God, busyness, carnal thinking and excuses. Please help me make willful daily decisions that please you and align my life according to your Word. I want to hear and obey your voice when you speak to me and my hearts desire is to please and touch your heart. In Jesus Name.

Next, you lead Him to your kitchen (place of preparation). What does He see? Does He see a table set with the finest of china

that obviously took time and special effort for you to make it look pretty and presentable for a King? Or because of your busy lifestyle of family, friends and work, maybe you simply stopped by a fast food restaurant and seem quite satisfied to present this before your King.

Re-examining this room: Begin to pray and thank God if you have taken the time and paid the price to have prepared a beautiful table before Him. Thank Him for the freedom in allowing you to make daily choices to yield to the work of the Holy Spirit and for the blessings that are in store for those who willing pay the price of sacrifice called "time". Ask the Lord to continue to keep those boundaries set all around you and not get caught up with distractions and the things of this world.

If you have gotten caught up in the fast paced rat race of life that can so easily take place if boundaries are not set, first recognize the weakness and second, ask the power of the Holy Spirit to help strengthen you in this area, so you can experience special times alone communing and dining with your King. You may need to arise early to seek the Kingdom of God first, before telephones, family and children start demanding your time and attention. Pray Matthew 6:33 over your life (Seek ye first the kingdom of God and His righteousness and all these other things will be added unto you.) and make it a priority to get in your secret place at all cost. Ask the Lord to forgive you of busyness and placing other things before Him. By aligning yourself with the presence and power of the Lord first thing in the morning, you are able to prepare your mind in advance for any upcoming attacks and situations that may occur during the day. Put on the full armor of God, dear Warrior, so you can walk in total victory each and every day!

Lastly, you show Him a very special room designed only for you and your King; the bedroom (a place of intimacy). But what does Jesus see? Perhaps your bed is made and dressed beautifully to

wow the King, all prepared for His eyes to see, letting Him know that He is your One and Only. Or, is it unkept, blankets tossed about that sends a message that there was simply not enough time to make the bed presentable for your King. As you show Him around, could there possibly be any embarrassing private things that you would not want him to see or discover or can you confidently present this room of intimacy without any guilt or shame?

Re-examining this room: Take a moment to tell the Lord right now how special and loved He is by you. Thank Him that He is so willing to come to a place of intimacy with you and begin to rejoice in the fact that His desire is for you. Ask the Holy Spirit to show you with your prophetic eyes, this place of intimacy, which will cause you to forget anything and everything of this world and be totally consumed with His deep love for you. This is where inner healing and change takes place in our lives.

Repent if there are things you have dabbled in behind closed doors, that is not pleasing to the Lord, and remove any stumbling blocks (call them out by name) that would hinder or offend the Holy Spirit. Thank Him for washing and cleansing you in these areas and freely receive the love, grace and mercy of God for your life. Break free from all bad habits so when you move in the dance, you will have no chains that can hinder your movement. God is love and He loves you dear Warrior. Receive His love with thanksgiving and be free!

Definition of Dance through Movement

To move rhythmically to music, typically following a set sequence of steps. To frolic, jump, skip, leap, walk, run, sway, whirl, twirl, contort, push, swing, spin, bend, reach, etc. I once took a missions trip with my dance school, *Breaking the Barriers Arts Academy*, to Barbados. It was an outreach event where 7

nations were represented for a weeks training in the dance and then released to the streets to witness. There was one night of this training I will never forget. Different people just got up to dance, and minister to one another when they felt led by the Lord. What made this night unforgettable was someone from my dance school, Karen Stills, got up and started to minister in movement prophetically (by the Spirit) without any music! I had never seen anything like that before and was deeply moved by her love for the Lord through movement. God had placed a song and melody in her heart that only she could hear and worship to. Needless to say, there wasn't a dry eye in the room! Most of us as dancers feel we need just the right music to minister to in order to be effective but God taught me that the "music" for the "worshipper" is locked deep down inside them and should be able to come out at any time, and in any circumstances; with or without music.

Origin of Dance

The first scripture pertaining to movement is found in Genesis 1:2 – "And the earth was without form, and void: and darkness was upon the face of the deep. And the Spirit of God *moved* upon the face of the waters." (emphasis mine) Movement is a vital part of God's character and spiritual DNA. It is the Spirit of God that "moves" and pushes away obstacles in our pathway that hinder our intimate relationship with God. The work of the Spirit also removes demons and sickness from the body, and will always lead us to keep moving in a forward motion to reach our ordained destiny. God never changes but He is always moving; it is imperative that we keep "in step" with Him, not lagging behind nor running ahead but keeping our eyes fixed on Jesus, the author and finisher of our faith! (Hebrews 12:2)

Some who have danced:

King David - 2 Samuel 6:14 and 1 Chronicles 15 and 16.
Miriam - Exodus 15:20-21.

Dance Performance versus Dance Ministry

Dance Performance: Dance that seeks to fulfill the lusts of the person dancing. It is done for self-fulfillment and satisfaction, to seduce or attract attention to self. A spirit of competition is usually attached to worldly dance, and should never be in operation in our ministry. A performance mindset does not place the emphasis on God but on self.

What makes a dance unacceptable before God is music with words that are anti-Christ; movements of hips, chest, and pelvis that are seductive or sexually provocative; the impure condition and motives of the heart of the dancer as well as improper clothing. Ultimately, what makes a dance unacceptable is any dance that could cause one to sin or stumble. **Please read Mark 6: 14-26. It gives us a clear warning in what can happen when operating in the flesh.**

Dance Ministry: *Dance that is pleasing to God because it is Christ-centered.* This dance does not magnify the dancer, rather the dance magnifies God and the dance is an expression of praise to God. Dance ministry takes the attention from the dancers and places the attention upon God. Through an anointed dance ministry, we can preach the Word of God through our movement, as well as, bring forth praise, glory and honor to our King! *There is great responsibility and accountability in what we do!*

Here are a few examples of types and purposes of dance ministry:
Praise dance (Psalms 149:3; 150:4)
Worship dance (Psalms 95:6)

Warfare dance (Psalms 18:29, 33-34, 37, 50; Psalms 149:7-9)
Dance of celebration (Deuteronomy 16:1, 6-11, 13-15; Exodus 23:16)
Dance of travail (Isaiah 66:8-11)
Prophetic dance (I Samuel 18:6-7)
Evangelistic dance (Tells a story)

Purposes of Patterns in the Dance

Here are some basic floor patterns you can use as you choreograph your dances:
- A Line Formation can be used for marching (warfare), unity and strength
- Diagonal Formations usually can be used to indicate progression
- Circle Formations can be used to indicate strength, protection, unity, and entrapment. Many Jewish dances use circle formations.
- "V" Formations may be used to indicate victory and to bring attention to the person at the point for any specific reason.
- Scattered Formations can be used to indicate confusion, a crowd scene, diversity and attacks. Many times if you have a larger dance ministry and are ministering in a small area, you may have to revert to this style of formation.

Scripture Memory Verses

Memorize the following verses below in your time of studying to be able to tell people scripturally why you do what you do. People who are more conservative may feel that dance is not appropriate and even sinful in the church. It is very important to lovingly point these people to what the Word of God says about the dance. By being able to freely quote these verses will show them that you have taken this ministry seriously, as

well as, becoming skilled in the Word of God. It's not about our opinions, likes or dislikes; God has made it very clear how He desires to be worshiped and one of the ways is through the dance. God has "released" us and "commanded" us to do so.

The Release to Dance:
Psalms 149:3 "LET THEM praise His name with dancing and make music to Him with tambourines and harp." (emphasis mine)

The Command to Dance:
Psalms 150:4 "PRAISE HIM with tambourine and dancing." (emphasis mine)

Who God says I am as a Minister of Dance:
Isaiah 61:6 "And you will be called priests of the Lord, you will be called ministers of our God." (I am not a dancer, but I am a priest and I minister unto God through the dance—therefore, the ministry of dance is a priestly ministry.)

My Responsibility as a Priest:
2 Timothy 2:15 "Study to show yourself approved unto God, a workman that need not to be ashamed, rightly dividing the Word of truth.

CHAPTER 3

The Ministry of Dance
and the Prophetic

Then Miriam the prophetess, Aaron's sister, took a
tambourine in her hand, and all the women followed her, with
tambourines and dancing.
(EXODUS 15:20)

Prophetic dance is a ritual dance in which the purpose is to obtain a communication from God or the Spirit. The dancer does not need specific dance training but he/she goes into a very uninhibited way of moving and the idea is that the movements are inspired, guided or directed by the Holy Spirit for the purpose of communication and encouragement of either the dancer(s) or watchers. The movement should be interpreted in the light of Biblical purposes and principles.

Prophetic dance is a distinct form of sacred dance in which revelation is received by the dancer from God and manifested into movement to bring forth a message to the people. It is important to understand that revelation is revealing or communicating divine truth through the Spirit of God to His people. God gives revelation through people in a number of creative ways such as writing, singing, drama, instrumental music and dance.

Revelation 19:10 says the testimony of Jesus is the spirit of prophecy (revelation). God is calling a prophetic people to hear His voice and respond in obedience to speak His words and demonstrate His purposes through movement.

Prophetic dance ministry is a calling to be able to see what the Father is doing in the spirit and reproduce it in the natural. In other words, the physical meets the supernatural and our bodies are used as a vehicle to connect with the Holy Spirit to manifest His Word to paint a picture or snapshot in the viewers' mind. Through the anointing, change and transformation can take place in the believers' or unbelievers' lives and God's power can be displayed through miracles, signs and wonders. This is the ultimate purpose of the ministry of dance.

From a Biblical perspective, Amos 9:11-12 *(¹¹"In that day "I will restore David's fallen shelter— I will repair its broken walls and restore its ruins— and will rebuild it as it used to be, ¹²so that they may possess the remnant of Edom and all the nations that bear my name," declares the LORD, who will do these things.)* and Acts 15:16-17 *(¹⁶"'After this I will return and rebuild David's fallen tent. Its ruins I will rebuild, and I will restore it, ¹⁷that the rest of mankind may seek the Lord, even all the Gentiles who bear my name," says the Lord, who does these things)* explains to us that the restoration of the tabernacle of David is so, that we may possess the remnant.

In the Hebrew, the word *possess* is *yaresh,* which means to occupy by driving out the previous tenants. Therefore, we can declare healing where there is sickness and freedom to those who are held captive.

Through prophetic body movements we can declare these things by:

1. Using our hands to clap and smite the enemy. God told Ezekiel to smite with his hands and stamp with his feet.

Ezekiel 6:11 *("'This is what the Sovereign LORD says: Strike your hands together and stamp your feet and cry out "Alas!" because of all the wicked and detestable practices of the people of Israel, for they will fall by the sword, famine and plague.)*

2. Using props as instruments of war. Isaiah 30:31-32 *(³¹The voice of the LORD will shatter Assyria; with his rod he will strike them down. ³²Every stroke the LORD lays on them with his punishing club will be to the music of timbrels and harps, as he fights them in battle with the blows of his arm.)*

3. Lifting our voices in praise to God. 2 Chronicles 20:19 *(Then some Levites from the Kohathites and Korahites stood up and praised the LORD, the God of Israel, with a very loud voice.)*

4. Dancing to tread on the enemy's head and take authority. Luke 10:19 *(I have given you authority to trample on snakes and scorpions and to overcome all the power of the enemy; nothing will harm you.)* Feet represent authority and taking land (see Joshua 1).

When ministering through these movements, the dancer needs to connect with the Holy Spirit, see what needs to take place in the spirit and then produce body movement to intercept what is going on in the atmosphere from the kingdom of darkness. Our human body becomes an instrument of war, fighting and interceding in the spirit on behalf of others. This is why it is imperative for the dancer to be an intercessor. Taking away the spiritual understanding of movement would be like someone attempting to shoot an arrow with no bull's eye as the target. Your dance will be ineffective to accomplish what the Lord has sent forth for it to do.

Additional Scripture Texts:

I Samuel 18:6-7, 2 Chronicles 20:21-22

Prophetic Soaking and Choreography

The word choreography comes from the Greek (khoreia) meaning "to dance in unison and to write". A choreographer is someone who creates and writes movement.

It is important to understand that when we go to choreograph our dances the following should be taking place:

1. We are taking quality time pursuing the presence of God.
2. We press in and pursue Him until we are right there at His feet gazing upon His face.
3. We then pull from the Holy Spirit and ask Him to reveal movement to the particular music selection
4. We grab hold of the vision and bring the Kingdom of Heaven down to earth.

Most dancers who have been trained in the world, obviously get their dance movements from their years of experience through man, but even as spectacular as worldly choreography can be, we are called to separate ourselves from worldly mindsets, as we belong to God's Kingdom and are not of this world. I am not saying that you should not take formal dance lessons, but for the worshipper, technique is not what is required but a heart of purity and love for the Lord is key. Also, a lot of times dance ministries are started by the person who has the "most dance experience." You need to guard against this mindset as the one with the most experience may not be the one God has chosen to lead the team. Consider the story of David when Samuel came looking for a king to anoint. 1 Samuel 16:1-13 says: (*¹The LORD said to Samuel, "How long will you mourn for Saul, since I have rejected him as king over Israel? Fill your horn with oil and be on your way; I am sending you to Jesse of Bethlehem. I have*

chosen one of his sons to be king." ²But Samuel said, "How can I go? If Saul hears about it, he will kill me." The LORD said, "Take a heifer with you and say, 'I have come to sacrifice to the LORD.' ³Invite Jesse to the sacrifice, and I will show you what to do. You are to anoint for me the one I indicate." ⁴Samuel did what the LORD said. When he arrived at Bethlehem, the elders of the town trembled when they met him. They asked, "Do you come in peace?" ⁵Samuel replied, "Yes, in peace; I have come to sacrifice to the LORD. Consecrate yourselves and come to the sacrifice with me." Then he consecrated Jesse and his sons and invited them to the sacrifice. ⁶When they arrived, Samuel saw Eliab and thought, "Surely the LORD's anointed stands here before the LORD." ⁷But the LORD said to Samuel, "Do not consider his appearance or his height, for I have rejected him. The LORD does not look at the things people look at. People look at the outward appearance, but the LORD looks at the heart." ⁸Then Jesse called Abinadab and had him pass in front of Samuel. But Samuel said, "The LORD has not chosen this one either." ⁹Jesse then had Shammah pass by, but Samuel said, "Nor has the LORD chosen this one." ¹⁰Jesse had seven of his sons pass before Samuel, but Samuel said to him, "The LORD has not chosen these." ¹¹So he asked Jesse, "Are these all the sons you have?" "There is still the youngest," Jesse answered. "He is tending the sheep." Samuel said, "Send for him; we will not sit down until he arrives." ¹²So he sent for him and had him brought in. He was glowing with health and had a fine appearance and handsome features. Then the LORD said, "Rise and anoint him; this is the one." ¹³So Samuel took the horn of oil and anointed him in the presence of his brothers, and from that day on the Spirit of the LORD came powerfully upon David. Samuel then went to Ramah.)

We read that Jesse brought forth all of his sons but one, to be anointed as King of Israel, but they were all rejected by God. They all appeared to physically fit the royal criteria, but God had

other thoughts on the matter. Here, it was a little shepherd boy, hand picked and chosen by God, to eventually lead the nation of Israel. This teaches us that man looks at the outer appearance, but God looks at the heart (*⁷But the LORD said to Samuel, "Do not consider his appearance or his height, for I have rejected him. The LORD does not look at the things people look at. People look at the outward appearance, but the LORD looks at the heart."*) It is the leader's character, not necessarily his/her skill that the Father looks for to lead His army. The leader should be chosen by God and not by man or out of popularity. You could place the most skilled in technique as a leader, yet he/she may be living a carnal life of sin. The leader is to be a representation of the character of God, where a team of God's people can follow and pattern their lives after him/her. The leader should be an intercessor, a prayer warrior and be able to stand through hard and difficult situations when they arise. Hopefully you have realized by now that the ministry of dance isn't even about the dance; it's the very last thing that we do!

God is so faithful and He is more than willing to release dances that have already been preordained in the heavenlies to be released here on earth for such a time as this. There are new dances just waiting to touch earth, but a costly price tag is attached to them, the cost is being in hot pursuit of His presence. The anointing will cost you everything. You must make a choice to either be a friend of this world which is hatred towards God and becoming His enemy, (James 4:4) or be a friend of God and have Jesus reveal the Father's kingdom to you. (John 15:15)

In this teaching segment you will discover keys for obtaining godly choreography. It's a spiritual discipline that I practice on a daily basis to get my choreography and to pursue the precious anointing of God. This technique is called "soaking". Soaking is a prophetic act that brings rest and refreshing to your soul as well as bring you in to the heavenly realms to see in the

spirit and commune with your Father. I have also discovered it increases a deeper love and hunger for the presence of the Lord. Biblical references are throughout this segment for studying.

Preparations to Soaking

As a dance ministry: If the place you are meeting has carpet or pews, you may use them to lie down on. You can also bring a pillow and blanket to lie on. Have each person on the ministry team lay on their back (lying prostrate before the Lord is a position of humility and rest). Close your eyes and try to clear your minds of the day's activities. If possible, you may want to dim the lights, to create an intimate atmosphere with the Lord. If younger children are present, have them lie down next to an older teenager or adult for accountability. The leader will determine how long your soaking sessions will be; averaging 15 to 30 minutes, depending on the amount of time you have scheduled to meet. (Some times we would do sleepovers at the church and have long extended times of soaking prayer.) There is actual soaking music you can purchase. Some suggestions would be: Todd Bentley: Soaking in the Secret Place, Voice of Healing and Marinating "Pickling in God's Presence". (Please be advised that the marinating CD is more on the "radical" prophetic side of soaking mixed with learning how to prophetically drink the New Wine in the River of God; lots of fun as well as brings you in to a place of intimacy). John Paul Jackson has a soaking CD called "The 365 Names of God". This is a great teaching tool to know the attributes of God. Heather Clark has amazing prophetic worship CD's and one of my favorite soaking CDs, is a husband and wife team, Alberto and Kimberly Rivera. This should help get you started.

Have some paper and a pen next to you in case the Lord releases a word or vision. The children actually get in to this exercise and love to soak. Release them to be free with their minds and what God is saying or showing them through any visions

they may receive from the Holy Spirit. I would always allow a small amount of time after the soaking sessions for people to share what the Lord did during their special time alone with God. While soaking, please do not ask the Lord for anything except for the Holy Spirit to come. This isn't a prayer session where you ask Him for things, but a time of lying back in His sweet presence and becoming like a sponge to absorb all of heaven being poured into you. In order for you to release the anointing to people, you must first receive it. Allow the Spirit of God to totally saturate you with His presence. This method may take some time and practice, but in the end it will be well worth the investment. The first portion of this lesson is to bring understanding to what you are doing and the second is a scripture that I have selected that describes some of the things that can take place during a soaking session. *So here we go! Let's jump in the river!*

Soaking in the River of Life

Purpose of soaking: (Colossians 3:2 – Set your mind on things above, not on earthly things.) If God were to ask you what the most valuable thing you could offer or give to Him, what would it be? Could it possibly be your spiritual gift, your house or your most valued possession? The answer should be your time, quality time alone with Him. Soaking does just that – it increases intimate time alone with God. Taking time out of your busy day/week to spend with the one you love, worship and serve will bring forth tremendous fruit in your life. When you have His presence, you have Him! Finding intimacy with the Father, Son and Holy Spirit is everything! The purpose for soaking is to be with Him so we can become more like Him – decreasing, so He may increase. John Arnott, pastor of the Toronto Airport Christian Fellowship says this in regards to soaking: "God is looking for lovers. He has many servants but

not many lovers. The only true love you need is a love for His presence."

Why we soak: (Psalm 23:1-3 says, *¹ The LORD is my shepherd, I lack nothing. ²He makes me lie down in green pastures, he leads me beside quiet waters, ³he refreshes my soul. He guides me along the right paths for his name's sake.)* As we learn to take time to quiet ourselves before the Lord and lie down in His green pastures, He has promised us that our souls would be restored. We soak because we simply just want to be with Him, a place where peace, joy and all the fruit of the Spirit abide (Psalm 29:11; Galatians 5:22-23). We soak because we hunger and thirst for more of His presence and desire to be more like Him (Matthew 5:6). We soak simply because we love Him, and want to spend time with Him. We also soak expecting to be touched, healed and empowered by God. Soaking is actually God's heart's desire for our lives. He loves to be with us, and spend quality time with us, so we are just practicing His heart's desire. Soaking allows us to be "saturated" with His presence, like that of a sponge. We fill up with His presence so we can generously spill it out onto those around us.

Soaking also teaches us spiritual disciplines – putting our agenda aside, focusing on Christ, taking every thought into captivity and learn how to hear the voice of God (John 10:27 says, *My sheep listen to my voice; I know them, and they follow me.*) There is a cry in our spirit that says, "More of You, Daddy! More of Your love! More of Your truth, more of Your presence revealed in me!"

Lastly, we soak because we desire to be changed. We are not satisfied staying the way we are. We want to go deeper! We want to experience the revelations, visions, and power encounters that the New Testament church experienced. We run hard after Christ and the Great Commission. We will not settle for anything less! Let's press into Him until this scripture manifests itself here on

earth once again; "And these signs will accompany those who believe: in my name they will drive out demons; they will speak in new tongues; they will pick up snakes with their hands; and when they drink deadly poison, it will not hurt them at all; they will place their hands on sick people, and they will get well" (Mark 16:17-18, NIV).

What can take place in a Soaking Session
Revelation 22

[1] "Then the angel showed me the river of the water of life, as clear as crystal, flowing from the throne of God and of the Lamb [2]down the middle of the great street of the city. On each side of the river stood the tree of life, bearing twelve crops of fruit, yielding its fruit every month. And the leaves of the tree are for the healing of the nations. [3]No longer will there be any curse. The throne of God and of the Lamb will be in the city, and His servants will serve Him. [4]They will see His face, and His name will be on their foreheads. [5]There will be no more night. They will not need the light of a lamp or the light of the sun, for the Lord God will give them light. And they will reign forever and ever. [6]The angel said to me, 'These words are trustworthy and true. The Lord, the God of the spirits of the prophets, sent His angel to show His servants the things that must soon take place' " (Rev. 22:1-6).

Verse 1 – Then the angel showed me (angelic visitation) the river of the water of life (water represents being washed, cleansed, purified) as clear as crystal (represents holiness, purity, transparency), flowing (represents always moving, not becoming stagnant) from the throne of God and the Lamb (the abundant source and place, whom and where we draw from).

Verse 2 – On each side of the river stood the tree of life bearing twelve crops of fruit, yielding its fruit every month (these trees beside the river brought forth life, yielding constant fruit) and

the leaves of the tree are for the healing of the nations (spiritual healing to all nations, to be reconciled back to God).

Verse 3 – No longer will there be any curse (the works of the devil will be destroyed). The throne of God and of the Lamb will be in the city (having full access to Him) and His servants will serve Him (willingly and lovingly because they know Him).

Verse 4 – They will see His face (beholding His beauty and majesty -- Matthew 5:8), and His name will be on their foreheads (possessing ownership, being set apart unto God alone).

Verse 5 – There will be no more night (darkness). They will not need the light of a lamp or the light of the sun for the Lord God will give them light (darkness/evil is removed and replaced with illuminating light/purity of the Son).

Verse 6 – The angel said to me, "These words are trustworthy and true (learn to trust God and His truths, and His truths will live within us). The Lord, the God of the spirits of the prophets, sent His angel to show His servants the things that must soon take place (God sends angels to speak to us and show us things).

In conclusion: *From this scripture text, soaking in the river of God produces the following:*
- Being washed clean, cleansed, purified and refreshed within (Rev. 22:1).
- Fulfillment when drinking deeply from the river that produces life and a spiritual awareness of whom the source flows from. Produces the fruit of the spirit in our lives.
- Life, constant fruit, healing to all who come in body, soul and spirit (Rev. 22:2).
- Destruction of the devil's work in our lives, deliverance and being set free. Direct access to Him, and understanding the call of servanthood to Him (Rev. 22:3).
- Seeing the face of God, beholding His glory and majesty,

being called by name, friendship and intimacy with God, being set apart for God, ready to do His will (Rev. 22:4).

- The removal of darkness from the evil one. Christ is light and the light of Christ exposes the darkness. Soaking causes us to examine our hearts, brings forth repentance and makes room only for light, casting out all darkness (Rev. 22:5).
- A deeper trust in God and His word (Rev. 22:6).
- Brings forth revelations and an increase in the seer anointing, such as visions, angelic visitations and the release of prophetic giftings.

The Prophetic Merging of the Arts
(dance, mime and instruments of war – please
see chapter five and six for more information
on Mime and Instruments of War)

In Joel 2: 28-29 we read that in these last days God will pour out His Spirit on ALL flesh. The Spirit of God is not a respecter of persons and will graciously be poured out onto men, women and children. It doesn't matter what age you are, you are never too old or young to receive and operate in the power of the Holy Spirit. It's not a "smaller" Holy Spirit that operates in youth and children but the same Spirit that operates in those of us who are more mature. This is why the Bible tells us not to look down upon the younger generation. (1 Timothy 4:12 says, *Don't let anyone look down on you because you are young, but set an example for the believers in speech, in conduct, in love, in faith and in purity.*) We need to reinforce how great the Father's love is for them and that they have a purpose and destiny to fulfill by using their gifts and talents to bring glory and honor to the Lord. If we fail to do this, they will be used for the purposes of the world never receiving the blessings that God has stored up for them. Let's take this generation back for the Kingdom of

God by using the arts and be open to the fresh new creativity of our youth!

We can flow in every area of the arts because the Word of God releases us to do so.

Some examples are:
1. Dance-Psalms 149:3 is the release and 150:4 is the command
2. Mime - Ezekiel chapters 4 and 12
3. Drama - Jeremiah 13:1-11
4. God speaks through visionary pictures - Jeremiah 18: 1-2 and the different parables of Jesus
5. Weapons: Flags-Psalms 20:5 Tambourines- Psalms 149:3 and 150:4

IN ORDER TO MERGE THE ARTS, WE MUST BE PEOPLE OF VISION and train ourselves to see with our spiritual eyes. A Biblical example of this is found in Isaiah 6:1-9.

In the year that King Uzziah died, I saw the Lord seated on a throne, high and exalted, and the train of his robe filled the temple. ²Above him were seraphs, each with six wings: With two wings they covered their faces, with two they covered their feet, and with two they were flying. ³And they were calling to one another:

"Holy, holy, holy is the LORD Almighty;
The whole earth is full of his glory."

⁴At the sound of their voices the doorposts and thresholds shook and the temple was filled with smoke. ⁵"Woe to me!" I cried. "I am ruined! For I am a man of unclean lips, and I live among a people of unclean lips, and my eyes have seen the King, the LORD Almighty." ⁶Then one of the seraphs flew to me with a live coal in his hand, which he had taken with tongs from the altar. ⁷With it he touched my mouth and said, "See, this has

touched your lips; your guilt is taken away and your sin atoned for." ⁸Then I heard the voice of the Lord saying, "Whom shall I send? And who will go for us?" And I said, "Here am I. Send Me!" ⁹He said, "Go and tell this people:

> " 'Be ever hearing, but never understanding;
> Be ever seeing, but never perceiving.'

God gave Isaiah this vision so he could understand his prophetic calling and commission (the authority to perform a certain task or duty). Let's take a moment and break down this Word to give us a better understanding of how God speaks to His people through visions:

Isaiah 6

Verse 1: I SAW THE LORD-God gave Isaiah "spiritual vision" to see the Lord in all His glory. Some very specific things he saw was God on the throne, the garment He was wearing and the activity all around Him. He saw the designs of heaven and how high, lofty, exalted and majestic God was. Just as the Lord released this "vision" to the prophet Isaiah, how much more for those of us living in the New Testament being filled with His Spirit, shall encounter visions in these last days.

Verse 2: ISAIAH SAW ANGELS-God gave Isaiah the ability to "see" what surrounded His throne. (Seraph angels: "burning ones" represents God's purity, holiness and glory that seemed to be on fire.) Matthew 5:8 tells us that the pure in heart "will" see God, therefore, it is imperative that we walk in the purity and holiness of the Lord in order to have the spirit of revelation released upon us. Take a moment right now and think about seeing God in all His glory. It's such an incredible sight to see that it should lead us to experience a reverential fear of the Lord in how to approach Him in our ministry.

Verse 3: HE HEARD ANGELS- we are capable of "hearing" in the spirit as well as seeing. Isaiah heard "Holy, holy, holy is

the Lord Almighty; the whole earth is full of His glory." Our sense of "hearing" can be activated in the spirit so we can hear the designs of heaven and words of instruction. Because He first loved us (1 John 4:10) we are now able to experience true love for Him and willingly live a consecrated life, totally separated from the world and fulfill the command to be holy as He is holy (2 Corinthians 6:17; 1 Peter 1:16) A life surrendered in loving obedience to Christ and His Word will produce good fruit and continual elevation in the spirit. This is how you are able to take yourself and your ministry into the next level. Let's not be satisfied where we are spiritually but always have a deep hunger for more of Him.

Verse 4: ISAIAH HEARD AND EXPERIENCED A POWER ENCOUNTER/MANIFESTATION-Isaiah heard and saw the glory of the Lord. The shaking and the smoke was a manifestation of the presence of God. When His presence shows up in your ministry, there should be a supernatural shaking in the spirit realm through your intercession and intimacy with Him. Do not be afraid if manifestations begin to happen as you go deeper with the things of God. This is completely normal and should be happening as a team when praying and soaking together. It's important for you to get your break through before going out to minister before Gods' people as whatever baggage or un-confessed sin you carry to the altars, those things will be released by you in the spirit into the atmosphere. An example of this would be, if you are sexually immoral or living in adultery, those unresolved sins have the legal right and permission to be released into the atmosphere or onto whoever is watching. Instead of releasing God's glory and the kingdom of light, we release iniquity and darkness. Make every effort to rid yourself of sin before going to the altars of God. This is why I made it mandatory to fast and pray days before we ministered; it was all part of the purification and preparation process.

In your ministry, ALL spirits of darkness must flee when the glory and the light of Christ is present. If God is not in it, the enemy has authority and access to operate in your ministry, which hinders the power from moving in miracles, signs and wonders and keeps those held in captivity in bondage. This defeats the purpose of the arts.

Verse 5: ISAIAH WAS DRAWN IN & RESPONDED TO THE VISION-experiencing visions from the Lord can lead you to repentance, humility, self-examination and cleansing. The above are all prerequisites for being a minister of the arts and should be experienced daily in our walk with the Lord. The closer we get to God, the more love and humility should be demonstrated in our lives; love for God and those around us especially to the body of Christ.

Verses 6 & 7: THERE WAS A SHIFT FROM BEING A SPECTATOR TO A PARTICIPANT- Isaiah went from just "seeing" in the vision to interacting in the vision. The coal that touched Isaiah's lips was essential as God called him to the office of a prophet; His lips needed to be "cleansed" in order to be the voice and mouthpiece of a holy God. This was all prophetic preparation for ministry. Understand as you prepare for ministry and cry out to God for mercy that He will respond to you and that your sin is atoned for. You no longer live in guilt and shame from your past but God advances you to move forward to fulfill your calling and destiny.

Verses 8 & 9: HEARD GOD'S VOICE AND WAS CHALLENGED AND COMMISSIONED- After self-examination, and repentance, Isaiah "heard the voice of the Lord." He was now ready to be commissioned and used by God as a prophet. God challenged him with the question "Whom shall I send? And who will go for US?" We, like Isaiah, should respond "Here I am, Send me!" We should all have the willingness

to answer the call of the Great Commission, testifying to the resurrection of our Lord and Savior Jesus Christ.

God has called each one of us to duty as priests and ministers (Isaiah 61:6). We must deliberately position and align ourselves to see, hear and receive from the Lord and as we seek Him with all our hearts. The Father will command a blessing and release His creativity upon us.

What does all this have to do with merging of the arts? Everything! We must be intentional in seeing, hearing and responding to the call of God for our ministries. We cannot limit or box Him in when it comes to creativity but be open to the work of the Holy Spirit to bring down the designs of heaven here to earth. God is sending us to bring forth heavenly messages so the manifest power of God can be released and revealed in this hour.

ACTIVATION EXERCISES
(Using your spiritual 5 senses to choreograph)
MERGING OF THE ARTS IS LIKE PUTTING TOGETHER DIFFERENT PEICES OF A PUZZLE TO CREATE A FINAL PICTURE. A great song to play that will help you flow with ease during this exercise is "Dance with Me" by Robert Stearns or "My Romance" by Karen Wheaton.

Here are some of your pieces you can use to dance with as you prophetically soak in the Spirit:
1. Dance (garments: what type of garments are you dancing in? What color is it?)
2. Flags/scarves/streamers/banners/billows/processionals (what colors did you choose?)
3. Chinese fans
4. Tambourines
5. Mime
6. Swords
7. Miscellaneous props (confetti, rose petals, feathers etc)

As you soak, try to use as many props as you can, as you choreograph your dance in the Spirit. By using them it can take a "simple" dance piece and make it into a full-blown arts production. Let's get outside the "norm" in our dances and start to move in the many different colorful, creative ways to demonstrate the power and glory of God.

Let's get started: If you can, lay prostrate before the Lord and begin to clear your mind of any clutter. Have a pen and paper to write down the visions the Holy Spirit will release to you during your soaking session. Before you begin, do the following:

1. Ask the Holy Spirit to come and release the Kingdom of God to you.
2. Focus on Him...remove distractions and press in. Speak directly to the Holy Spirit as He will start to reveal things to you.
3. Try using all your 5 physical senses in the spirit (smell, hearing, taste, touch and sight).

PLAY YOUR MUSIC

WHAT DO YOU "SEE" AS FAR AS MOVEMENT AND PICTURES (color, garments, props etc)?

WHAT DO YOU "HEAR" IN THE SPIRIT? (music...is it warfare, worship, high praise, Angels/God speaking?)

IS THERE ANYTHING EDIBLE? (is someone eating/drinking something...grape juice, wine etc?)

DO YOU "SMELL" AN AROMA? (oils, flowers?)

IS THERE SOMETHING TO HOLD, FEEL OR TOUCH? (props, instruments of war, keys, trinkets from God such as jewelry, gemstones etc.)

4. Write down what you saw. Be very specific even if you don't understand it.
5. Lastly, thank the Holy Spirit for what He's given you whether it's a little or a lot. It can take time to spiritually develop this gift but it is worth working at.

ADDITIONAL THOUGHTS: Selecting the appropriate music is essential. You must take the time to pray, seek the Lord and release it at the APPROPRIATE time. God may give you a song to dance to, but the timing of the presentation is very important. Many times the Lord would give me a song, and even after He gave me the choreography, He would not always release me to dance to it right away. There were songs that were in my "belly" for 2 years before they were ever danced to, so be patient and don't run ahead of God. His timing is perfect.

You will need to listen to the music over and over again until it is in your spirit. You will know when it is in your spirit when you can sing every word to the song. You should be able to dance to a song WITHOUT the music...that is how much it should be in you.

Practice and exercise these principals as a team. WORK TOGETHER! Leaders, be open to your team's creativity and suggestions. Step out of the box (ordinary) and try new things! (Especially music). If you can, work alongside of your Pastor to merge your arts ministry with his sermons. Take the Pastor's scripture he will be preaching and pray over it. It is very powerful when the worship music, the arts and the Word flows together during a service...operating in one spirit and one accord. By flowing together in unity we give the Holy Spirit access to move in our services to save the lost, heal the sick and broken and to set free those in captivity.

Priestly Garments

*"Make sacred garments for your brother Aaron to give him
dignity and honor"*
(EXODUS 28:2)

God is a God of order. We can clearly see God's order in creation
as well as how He established the 12 tribes of Israel. He gave
very specific instructions when building the tabernacle, as well
as, to those who were permitted to serve as priests before the
Lord. God had made it very clear that the priests were to come
from the tribe of Levi and would be descendants of Aaron.

After the completion of the tabernacle, we read in Exodus 28
how God instructed Moses on what type of garment that was to
be worn by his brother Aaron and his sons in order to approach
God and perform their priestly duties in the tabernacle.

Exodus 28:6-14. *(⁶"Make the ephod of gold, and of blue, purple
and scarlet yarn, and of finely twisted linen—the work of skilled
hands. ⁷It is to have two shoulder pieces attached to two of its
corners, so it can be fastened. ⁸Its skillfully woven waistband is
to be like it—of one piece with the ephod and made with gold,
and with blue, purple and scarlet yarn, and with finely twisted
linen. ⁹"Take two onyx stones and engrave on them the names of
the sons of Israel ¹⁰in the order of their birth—six names on one*

stone and the remaining six on the other. ¹¹Engrave the names of the sons of Israel on the two stones the way a gem cutter engraves a seal. Then mount the stones in gold filigree settings ¹²and fasten them on the shoulder pieces of the ephod as memorial stones for the sons of Israel. Aaron is to bear the names on his shoulders as a memorial before the LORD. ¹³Make gold filigree settings ¹⁴ and two braided chains of pure gold, like a rope, and attach the chains to the settings.)

The Ephod: Is a priestly garment and a type of apron that extended to the knees and was elaborately embroidered with two pieces, back and front, joined at the shoulders with a band at the waist. On each shoulder strap, there was a stone with six of the 12 tribes of Israel engraved on it. The ephod was worn over the priest's robe.

Exodus 28:15-30. *(¹⁵"Fashion a breastpiece for making decisions—the work of skilled hands. Make it like the ephod: of gold, and of blue, purple and scarlet yarn, and of finely twisted linen. ¹⁶It is to be square—a span long and a span wide—and folded double. ¹⁷Then mount four rows of precious stones on it. The first row shall be carnelian, chrysolite and beryl; ¹⁸the second row shall be turquoise, lapis lazuli and emerald; ¹⁹the third row shall be jacinth, agate and amethyst; ²⁰the fourth row shall be topaz, onyx and jasper. Mount them in gold filigree settings. ²¹There are to be twelve stones, one for each of the names of the sons of Israel, each engraved like a seal with the name of one of the twelve tribes. ²²"For the breastpiece make braided chains of pure gold, like a rope. ²³Make two gold rings for it and fasten them to two corners of the breastpiece. ²⁴Fasten the two gold chains to the rings at the corners of the breastpiece, ²⁵and the other ends of the chains to the two settings, attaching them to the shoulder pieces of the ephod at the front. ²⁶Make two gold rings and attach them to the other two corners of the breastpiece on the inside edge next to the ephod. ²⁷Make two*

more gold rings and attach them to the bottom of the shoulder pieces on the front of the ephod, close to the seam just above the waistband of the ephod. ²⁸The rings of the breastpiece are to be tied to the rings of the ephod with blue cord, connecting it to the waistband, so that the breastpiece will not swing out from the ephod. ²⁹"Whenever Aaron enters the Holy Place, he will bear the names of the sons of Israel over his heart on the breastpiece of decision as a continuing memorial before the LORD. ³⁰Also put the Urim and the Thummim in the breastpiece, so they may be over Aaron's heart whenever he enters the presence of the LORD. Thus Aaron will always bear the means of making decisions for the Israelites over his heart before the LORD.)

The Breastpiece: In the Hebrew it means to sparkle and this was a square on which were placed 12 small precious stones in four horizontal rows of three stones each. On these stones the names of the 12 sons of Israel were engraved and represented the priest symbolically carrying the burden of the whole nation. Also in this pocket was to hold the Urim and Thummim and was to be worn over the heart of Aaron.

Urim and Thummim: Were used by the priest to make decisions. These names mean "curses" and "perfections" and referred to the nature of God whose will they revealed. They were kept in a pouch and taken out or shaken out to either get a yes or no decision when seeking an answer from God.

Today, Jesus is our great High Priest who bears our burdens on His shoulders, making intercession for us day and night before our Heavenly Father. We now have direct access to Him and may approach the throne of grace at any time with confidence and boldness, because of the sacrifice of Jesus' life. We no longer have to cast lots when making decisions but can go directly and boldly before the throne of grace, praise the Lord!

Other Types of Priestly Garments:

Read Exodus 28:31-42.
Robes (verse 31)

Accessories attached to the robes (verse 33) were pomegranates and gold bells: Many people have wondered why God would instruct Aaron to wear pomegranates that were woven with fine twined linen and pure gold bells on the hem of his priestly garments and what it means symbolically. It could mean several things but this is what I have come to the conclusion of what it could represent pertaining the ministry of the dance: A pomegranate is a fruit with many seeds. It symbolizes the worship of God and righteousness. Therefore, in our ministry, there should first be the evidence of the fruit of the Spirit in our own lives as well as in our ministry. Jesus gave strong warnings about the danger in not bearing this fruit in John 15, so therefore, we need to make sure we allow the Holy Spirit to help us align our personal lives with Galatians 5: 22-23, as well as, produce good fruit in the ministry. The many seeds represent sowing and scattering to reap a harvest. We should be seeing salvations, personal and congregational breakthroughs as well as healings taking place during our times of gathering.

Gold bells: Gold represents glory and the Holy Spirit. It also symbolizes the refiner's purification by the Spirit of God. Bells symbolize an object of announcement, warning or call and heavenly host. As we prepare to minister in dance, let's keep an open heart to the work of the Holy Spirit to come in and burn up by fire anything that may grieve Him. By doing so, we can be that clean vessel that God can use to bring forth a message of prophetic warning, announcement or call from the heavenly host. Allowing the Spirit's fire to refine us, we come out like pure gold, full of God's glory!

Head pieces (verses 36 and 37)
Sashes (verse 39)
Tunics (verse 40)

Linen undergarments (verse 42)

These garments were to be worn to cover the flesh, which brought dignity and honor to the Lord.

Priestly Garments and the Ministry of Dance

"But you are a chosen people, a royal priesthood,
a holy nation, a people belonging to God ..."
(1 PETER 2:9)

Because the ministry of dance is a priestly ministry, we should therefore present ourselves as priests before the Lord with "dignity" and "honor" at the altars of God. As we approach the King in worship, our attitudes and motives need to be pure, and our attire needs to be set apart from the world. Our garments are "sacred" and should not be looked upon as the same as our everyday clothing. Priestly garments should be handled with care, honor and respect. (Ezekiel 44:19 says, *When they go out into the outer court where the people are, they are to take off the clothes they have been ministering in and are to leave them in the sacred rooms, and put on other clothes, so that the people are not consecrated through contact with their garments.*)

Our garments should never draw any attention to the configuration of our physical bodies (body suits, flesh colored garments) as to bring in a spirit of lust. Priestly garments are to be worn to show proper respect and the holiness of God. We want the people of God to see His Kingship and priesthood in us through our movements. Applying any type of garment that would entice or misrepresent this priestly ministry in any way should be forbidden, and proper correction should be brought forth. We need to keep it holy! "Therefore, come out from them and be separate," says the Lord. "Touch no unclean thing, and I will receive you" (2 Corinthians 6:17).

AVOIDING LEGALISM: Please do not get caught up in a "legalistic" mindset when preparing to minister at the altars of God. In no way do I believe that we should approach the King of kings looking homely or unattractive. We are royal priesthood and daughters of the King and therefore, dressing "holy" does not refer to not "beautifying" oneself. Queen Esther went through a year of beauty treatments before she even approached her king for the first time; I guarantee she looked absolutely stunning and radiant on that special day.

I have sat under teachings that prohibited women to wear earrings, makeup and artificial nails. We must remember that God looks at the heart of man and not the outward man, and therefore, we are not to judge others by their appearances. Someone who looks and is dressed very plainly may be considered "holy" in the eyes of man but her heart may be full of sin. Leaders, please do not put yokes of bondage on your dancers in this area. It's ok to feel and look beautiful as you approach the altars of God; after all, God is the audience and He sits on His royal throne.

On the flip side of these statements, we should examine our hearts and ask the Holy Spirit if He approves of our motives. If I am wearing big earrings or jewelry, it could be a distraction to me as the dancer because I must be able to move freely in my movements, which could also be a distraction to the one who is watching. The focus then becomes on "man" rather than Christ. If I am wearing things to "be seen" by man for attention, this is when it is wrong but please, let us not throw the baby out with the bath water! We no longer live in the Old Testament; living under the curse of the Law but we have been set free and now live under grace. Let's learn to appreciate each other's uniqueness and not judge one another by our outward appearances.

1 Timothy 2:9 speaks on women not adorning themselves in their outer man, but let us not take this scripture out of context.

Paul was referring to the godliness of the "inner man" of the woman, rather than her outward appearance. His point was that our time and attention should be spent working and caring for the spiritual condition of our heart and not so much on the flesh.

We learned in this chapter earlier that it is ok to "sparkle" and "shine" at the altars of God. (breastpiece) We represent Christ, the King of kings and Lord of lords. We are the "Bride of Christ". I have never seen a bride that did not sparkle and shine on her special day! She takes great effort and time to make herself beautiful for her bridegroom; how much more for our Majestic Bridegroom! So, go ahead and put on your sparkled sashes and headpieces and dance with all your might in the royal courts of the King...*after all, we are the Dancing Warrior Bride!*

Old and New Testament Guidelines in Preparation to Minister in Dance

In Exodus 28:40-43 and chapters 29 and 30, God instructed the priests to consecrate and anoint themselves and offer up burnt offerings.

Exodus 29:1-2 – *[1]"This is what you are to do to consecrate them, so they may serve me as priests: Take a young bull and two rams without defect. [2]And from the finest wheat flour make round loaves without yeast, thick loaves without yeast and with olive oil mixed in, and thin loaves without yeast and brushed with olive oil.* They had to prepare certain types of food before they could even approach the altars of God. Today, we are no longer under the Levitical law of eating, but it would do us well to be careful and use wisdom when eating food as it will have an effect on our physical bodies. We want to concentrate on food that will give us energy (living foods) and clarity of thinking. (See chapter 8 for conditioning the body and nutrition)

Exodus 29:4 – *⁴Then bring Aaron and his sons to the entrance to the tent of meeting and wash them with water.* The priests had to "wash" (purify) themselves with water before entering the temple. In the New Testament our washing and purifying ourselves consists of:

1. Going before the Lord, asking the Holy Spirit to search our hearts
2. Allow the conviction of the Holy Spirit to bring repentance and forgiveness of sins
3. Receive that forgiveness and walk in total liberty and freedom from all past guilt and shame.

Exodus 29:5 – *⁵Take the garments and dress Aaron with the tunic, the robe of the ephod, the ephod itself and the breastpiece. Fasten the ephod on him by its skillfully woven waistband.* Then they would dress themselves in their appropriate garments. Taking a look again at 1 Timothy 2:9, women of God are commanded to dress modestly and to avoid all appearances of evil. Once again, how you live your life and present yourself does matter as others are watching your walk. What type of mixed messages would we be sending if we are dressed in our holy garments at the altars of God and when we exit out of the church doors, we are improperly clothed? This is where a lot of people from the world look at the church and accuse us of being hypocrites. God wants to bring a change in this area to where we will walk in consistency with what the Word of God says, and continue to teach modesty in spite of living in a seductive world.

Exodus 29:7 – *⁷Take the anointing oil and anoint him by pouring it on his head.* In the New Testament not just our heads are anointed but our ENTIRE being! Jesus, the Messiah (anointed one), is in us (John 15:4), on us (Isaiah 61:1) and with us (Matthew 28:20)! As children of God, we are all able to flow in His resurrection power in our ministries. The anointing is no

longer just given to priests, prophets and kings, but to all who choose to come to Him. The anointing is for your gift and your life.

Exodus 29:37 – *³⁷For seven days make atonement for the altar and consecrate it. Then the altar will be most holy, and whatever touches it will be holy.* Notice the overwhelming emphasis on the holiness of God. The priest, the clothes, the tabernacle and the sacrifice had to be cleaned and consecrated. There was a demand of preparation that God required of them. The priest would make sure that he would enter the Holy of Holies with proper order. To do anything less would cost him his life.

In contrast, today we tend to take God for granted, rushing into worship and treating Him with almost "casual disregard", but dear brothers and sisters in Christ, we worship the Almighty Creator and Sustainer of the universe! We need to always remember this profound truth as we prepare to minister at the altars of God, taking what we are called to do very seriously. Preparing oneself to minister before a holy God will once again require us to have a deep desire to consecrate ourselves unto the Lord and walk in repentance, reverence and a constant fear of the Lord. Only then will we be truly ready to minister as priests and capture the Father's heart!

Practical Ways of Preparing to Minister in Dance

On the week of ministering, fast and pray for those you will be ministering to. Ask the Lord what needs to be done in the spirit to accomplish His will in that particular service/event. Diligently be studying God's Word.

Avoid distractions and stay focused. Saturate yourself with the music you will be ministering to throughout the week. Remove

all obstacles that do not pertain to you ministering as much as possible.

Stay in right relationships with those around you, especially family members. The greatest warfare will be within your household. *Do whatever possible to be at peace. Watch your tongue. Bless and do not curse.*

Be prepared to work hard on final practices...**no complaining.**

Prepare and lay out all your priestly garments the night before. Iron out wrinkles! I also will anoint my garments with oil, when led by the Spirit, to do so before putting them on. I pray and ask the Holy Spirit to linger on my garments with His presence while moving in dance.

Be in bed at a decent hour (by 10pm) and get a good night's sleep.

The Day of Ministering, upon arising, greet the Holy Spirit and tell Him how much you love Him and will need Him today.

Eat a healthy breakfast such as fruit, oatmeal, etc. Refrain from junk foods and refined sugar. Be sure to pack plenty of bottled water for your event.

Arrive early or on time at church and be ready to minister. Bring in a positive attitude to spread to the team.

Listen and follow leadership very carefully. Eliminate all unnecessary chatter before and during ministry time and stay completely focused on what God is calling you to do. Many times I would have my team soak in the song we were ministering to several times to get it fresh in their spirits. Then come together as a team and pray for one another. Ask the Holy Spirit to dance with you!

Give God 100% and dance with all your might! Never take a bow at the end of the dance, as we must be very careful that God receives all the glory, not us! Bowing before man gives the appearance of you performing and your dance being a show or performance. **We want to do everything possible to retrain the minds of the people of God that what we do is ministry and not entertainment.**

After ministering, gather back together and pray thanking God for what He has done and accomplished through you. Bind up any backlashing spirits that would try to come and operate in your lives. Cover each other with the blood as well as your household, finances, pets etc. Celebrate your victories and learn to overcome any defeat.

A Clarion Call to Arms...
Weapons of War!
(tambourines, flags, streamers, billows, fans and colors)

Blessed is He that trains my hands for
war and my fingers for battle.
PSALMS 144:1

THE WORD OF GOD TELLS US
...that the weapons of our warfare are not carnal, but
mighty through God to the pulling down of strongholds.
(2 CORINTHIANS 10:4)

The word weapons, in the Greek, is *hoplon* (hop'-lon) meaning a tool, offensive for war, armor, instrument. When we engage in battle against the kingdom of darkness, our weapons of warfare are not fleshly weapons such as handguns, knives, bombs etc. but are spiritual. Our offensive tools against this kingdom are, our praise, worship, the Word of God and prayer. By practicing these things daily, His Warrior Bride is assured absolute victory! The combat zone can get pretty messy and exhausting at times but there is nothing more rewarding than co-laboring with the General to see to it that satan's kingdom is defeated. When

you gave your life to Christ, whether you knew it or not, you immediately enlisted yourself in the Lord's army; you became His *"Onward, Christian soldier marching as to war, with the cross of Jesus, going on before! "*

This teaching segment will bring clear revelation of your role, as a foot soldier on the battlefield of life. You will discover your worth and role in tearing down the kingdom of darkness and everything that God has provided for you to fight and be an overcomer. I would highly recommend reading the book *"Weapons of Mass Destruction"* by Dr. Elizabeth Brown. I first heard of this teaching in her seminar one day that has forever changed my life. She is an amazing woman of God with deep revelation on this subject. Here are a few things she imparted to me that day:

Worship has a Physical Body; that would be you!

Romans 6:13 says, *(Do not offer any part of yourself to sin as an instrument of wickedness, but rather offer yourselves to God as those who have been brought from death to life; and offer every part of yourself to him as an instrument of righteousness.)* The word "instruments" is relating to our physical body parts (hands, feet, etc.).

In other words, God has intended for us to use our physical bodies as a weapon. It could therefore be properly translated as follows:

Do not offer the parts of your body to sin, as instruments (weapons) of wickedness, but rather offer yourselves to God, as those who have been brought from death to life, and offer the parts of your body to Him as instruments (weapons) of righteousness (Romans 6:13).

Our physical body is made up of many parts: limbs, hands, feet,

mouth, eyes, brain, etc. Every part is to be used to glorify the Lord. God created every part of our being to "worship" Him.

Comparing your Body Parts to the Different Gifts:
Eyes are your discerners

Hands are the ministry of help, service and distribution (giving)

Shoulders are the administrators

Mouth – prophets, pastors and exhorters

Feet – evangelists and apostles

Mind – teachers

Heart – mercy and compassion givers

Body Parts Pertaining to the Arts:
Mouth – singers/actors/prophesying

Hands – musicians/painters/sculptors

Feet – movement artists (dancers)

God can use these parts as instruments of worship and warfare.

God's Armory (War Chest): This scripture will enlighten your eyes to see the calling of warfare on a movement artists life as well as the importance of being fully skilled and equipped in this ministry. The Lord is sending us right on the frontlines of spiritual warfare!

"The Lord has opened His armory (treasure, warchest/ storehouse/a place where arms are kept) and brought out the weapons of His wrath, for the Lord God of Hosts (Yahweh Tsebaoth – God's military name) has a work to do in the land of the Chaldeans (God's enemies or those that oppose God's people)" (Jeremiah 50:25).

Jeremiah 50:25 and the Arts:
When God is ready to bring forth judgment and do battle against the kingdom of darkness, prophetically, He will open up His war chest and select whatever weapons of choice to defeat His

enemies. An example of this from the Bible would be Exodus 7:9-12, where God instructed Moses to cast down his rod (weapon) against Pharaoh and all his wise men, which was transformed into a snake. Moses' rod represented God's authority in his hand. We know in the end that God prevailed over all their gods by His rod, swallowing up all His enemies' rods (verse 12). You may ask yourself, "Why did God choose to put something in Moses' hand to bring defeat to his enemies? Couldn't God have just done it without the rod? Of course He could, but it was a test of Moses' obedience to the Lord, AND it was also a prophetic act which God demonstrates so many times throughout the Bible. We cannot always know in advance what God will choose to use to defeat His enemies but we can be thoroughly equipped, be on "stand by" and on call for active duty; ready to do battle when the clarion call to arms is signaled. This also teaches us that we cannot box God in; He is God and can do whatever He wants, whenever He wants. He looks for those who are faithful and obedient to answer the call and go to war together on His behalf. Isn't it awesome that God would choose us to co-labor together with Him?

Body Parts used as Weapons of War

MOUTH: Our mouth is used:

TO PREACH the Word (Acts 2:38-41 says, *[38]Peter replied, "Repent and be baptized, every one of you, in the name of Jesus Christ for the forgiveness of your sins. And you will receive the gift of the Holy Spirit. [39]The promise is for you and your children and for all who are far off—for all whom the Lord our God will call." [40]With many other words he warned them; and he pleaded with them, "Save yourselves from this corrupt generation." [41]Those who accepted his message were baptized, and about three thousand were added to their number that day.)*

– The results bring repentance, salvation, receiving the Spirit and expansion of the Kingdom of God.

FOR PRAYER and intercession (James 5:16 says, *Therefore confess your sins to each other and pray for each other so that you may be healed. The prayer of a righteous person is powerful and effective.*) – Results bring a shift, change and reverse in the spirit against the kingdom of darkness. Prayer is used to hurl spiritual missiles into the enemy's camp.

TO GIVE SHOUTS OF PRAISE (Psalm 149:5-9 says, *⁵Let his faithful people rejoice in this honor and sing for joy on their beds. ⁶May the praise of God be in their mouths and a double-edged sword in their hands, to inflict vengeance on the nations and punishment on the peoples, ⁸to bind their kings with fetters, their nobles with shackles of iron, ⁹to carry out the sentence written against them— this is the glory of all his faithful people. Praise the LORD.*) – This is worship/warfare…singing is worship, double-edged sword (Word) is warfare. When combining the two, God inflicts vengeance and judgment on people and those in authority who are His enemies. This is a great picture of the "Warrior Bride." An example of this in action is when Paul and Silas sung their way out of prison (bondage). The Lord intervened and rescued them (Acts 16:25-26).

TO MAKE A DECLARATION (Psalm 89:1 says, *I will sing of the LORD's great love forever; with my mouth I will make your faithfulness known through all generations.*) – Proclaiming God's faithfulness to all generations.

AS A WEAPON OF WAR (Isaiah 49:2 says, *He made my mouth like a sharpened sword, in the shadow of his hand he hid me; he made me into a polished arrow and concealed me in his quiver.*) – My mouth used like a sharp sword.

FEET: (Hebrew -- Regal) possession/possess (Hebrew -- *Yaresh*) – To occupy by driving out the previous tenant. To terrify, disinherit, cast out, to destroy (Joshua – Chapters 1, 3 and 10).

USED IN WARFARE (Malachi 4:3; Psalm 149:6-9; Luke 10:19)
SIGN OF AUTHORITY (Psalm 8:6)
FAVOR (Psalm 18:33)
STEADFASTNESS (Psalm 66:9)
HANDS: TO CLAP (Psalm 47:1-3 says, *¹Clap your hands, all you nations; shout to God with cries of joy. ²For the LORD Most High is awesome, the great King over all the earth. ³He subdued nations under us, peoples under our feet.)* – Hebrew: Taw-kah – to smite, to drive a tent peg or nail, to strike, to thrust. When we clap our hands, they are being used to defeat the enemy, and to take authority in the atmosphere during worship and offering up praise unto the Lord.
USED AS A WEAPON OF WAR (Psalm 18:34) – "He trains my hands to make war…" God teaches and instructs us how to successfully conquer in combat.

Objects Used for Warfare in the Treasure Chest

THE "WIND" INSTRUMENTS (Breath of God)
1. Trumpets/Shofars (Revelation 1:10; Joshua 6:5) – Represents the voice of the Lord. When shofars and trumpets are blown, God comes down and wars on our behalf (Nehemiah 4:20). Shofars are also used to bring down the glory!

When someone is anointed by God to blow a trumpet, or any wind instrument, the very breath of God (Holy Spirit) prophetically flows through that instrument to bring a release from heaven.

From a Biblical perspective, in Genesis 1, we read that God spoke and all things came into existence (And God said…). Creation was released by the Spirit of God; His very breath.

Genesis 2:7 – *God breathed and man became a living being. **Life was released.***

Ezekiel 37:9-10 says, *⁹Then he said to me, "Prophesy to the breath; prophesy, son of man, and say to it, 'This is what the Sovereign LORD says: Come, breath, from the four winds and breathe into these slain, that they may live.'" ¹⁰So I prophesied as he commanded me, and breath entered them; they came to life and stood up on their feet—a vast army.* – Ezekiel spoke (prophesied—used his mouth) to the four winds of the earth and the valley of dry bones came to life. **Resurrection power was released.**

HAND INSTRUMENTS:

1. HARP: Used by David for healing and deliverance (I Samuel 16:23). The harp was also used for judgment and punishment (Isaiah 30:31-32).

2. TAMBOURINE: (timbrel, tabret) is a percussion instrument; the striking together of two bodies.

The Origin of the Tambourine: Read Ezekiel 28:13-15 (KJV). When Lucifer held his position as the anointed cherub on the Holy Mountain of God, one of his roles was to provide that covering of worship before God. *"...The workmanship of thy tabrets (tambourines) and of thy pipes was prepared in thee in the day that thou was created."* In verse 13, when it talks about the workmanship of his tabrets, that word indicates satan's occupation, his business, his service and, his religious use. His job was to produce God's sound...*a heavenly sound!*

When he fell, the instrument and spirit of worship fell with him. God did not take it from him; it's still in him. That is why today, when you hear rhythm in worldly music, it sounds so perverted in addition to the unholy lyrics. He (satan) despises the fact that we are made in the image of God (angels are not) and were created to worship God. He's been fired from his position and replaced by the people of God!

In my opinion, I believe that is why there is so much warfare and

"Lucifer" (prideful) spirits in worship ministries today. (I will ascend; I will exalt myself.) There is strife, discord and jealousy within the musicians and satan knows that if he can keep them divided, he has won. Worship takes us to the very throne room of God! It tears down strongholds and principalities. Worship also chips away even at the hardest of hearts as it brings change and transformation in people's lives. No wonder there is so much warfare going on in it.

He (satan) knows if the people of God come together in harmony and unity with the spirit of worship in their hearts that every stronghold and principality of darkness would be destroyed. Miracles, signs and wonders would follow and the work of the Kingdom of God would be accomplished here on earth, especially to win the end time harvest.

How is the tambourine used as a weapon?
Our bodies (anointed by God) hit and strike the body of the enemy (instrument owned by satan). When we pick up and shake this instrument, it immediately awakens satan's kingdom. He recognizes the sound and comes to attention because he knows it rightfully belonged to him. When we shake it, we shake it as "mockery" in the face of the enemy. When we "hit" it, we send "blows" to the kingdom of darkness.

We must always remember when playing the tambourine that our works of service is to produce the sound of God. It is not a toy; it is an instrument of war that needs to be carefully handled. Anyone who desires to minister with the tambourine should be skilled in the Word and an intercessor. When satan hears it, he's ready to do battle to take it back!

Used as a Prophetic Instrument: Exodus 15:19-20 says, *[19]When Pharaoh's horses, chariots and horsemen went into the sea, the LORD brought the waters of the sea back over them, but the Israelites walked through the sea on dry ground. [20]Then Miriam*

the prophet, Aaron's sister, took a timbrel in her hand, and all the women followed her, with timbrels and dancing. After Moses and the Red Sea experience, Miriam, the prophetess, and all the women picked up their tambourines and made prophetic proclamations of worship. This was a dance of victory!

Used for Battle/Punishment/Judgment: Isaiah 30:31-32 says *³¹The voice of the LORD will shatter Assyria; with his rod he will strike them down. ³²Every stroke the LORD lays on them with his punishing club will be to the music of timbrels and harps, as he fights them in battle with the blows of his arm.* At times, God will call us to pick up our tambourines and make rhythmic music as God strikes the back of the enemy. This is when it gets really fun!

Used as an Evangelistic Tool:
The founder of the Salvation Army, William Booth, had tambourine brigades. He saw that people had needs: food, shelter, clothing, etc., and would have a tambourine brigade play and march down the street. The noise and the sound would attract the crowds, and the people would follow them like a spiritual Pied Piper back to the refuge shelters where they would get their personal needs met. They would hear the Gospel message preached and surrender their lives to the Lordship of Jesus Christ. This is how the Salvation Army became well known.

3. FLAGS/STANDARDS/BANNERS: (Hebrew: *Dagal*)

Psalm 20:25 – *"We will shout for joy when you are victorious and we will lift up our banners in the name of our God."*

Standard: A rod, symbol carried on a pole, and raised high in the air, much like a flag, to rally a tribe or a group of warriors in battle. Read Numbers 1:1-4; 52; 2:1-2.

Used for military purposes, when the Israelites marched according to their military and family divisions. Each family

had their own standard and was assigned to stay under that standard with their assigned leader. We can clearly see the order of God in this Scripture and to move outside of this order would ultimately create chaos in the camp and open doors for the enemy to attack.

Banner: A flag or ensign, streamer or emblem attached to the end of a standard (rod). Used mostly for military campaigns.

Prophetically, God used the raising of Moses' hands, thus becoming a living banner symbolizing God's presence to help His people win the victory (Exodus 17:8-16). After the battle, Moses built an altar and called it "Jehovah-Nissi" – The Lord is my banner (Exodus 17:15).

PURPOSE OF BANNERS:
As a rallying point (John 12:32 says, *And I, when I am lifted up from the earth, will draw all people to myself.*)

Prophetic proclamation of the truth (Numbers 21:8-9; John 3:14, Psalm 60:4) and victory (Jeremiah 50:2). Prophetic fortress (Jeremiah 51:12).

Instruments of worship (Banners that proclaim the names of God and who He is). Ex: Jehovah Jireh: God My Provider

Instruments of war (Isaiah 31:9; Jeremiah 4:6, 51:27). *"When the enemy shall come in like a flood, the Spirit of the Lord shall lift up a standard against him"* (Isaiah 59:19).

Instruments of intercession (The rod of God -- the Hebrew word for rod is *matteh*; a branch, rod, ruling scepter). We can take flags and banners as prophetic symbolism and pray for nations or whatever is written on the banner.

Healing instrument (Numbers 21:4-9). In the Old Testament, when the brass serpent was lifted up, the people were healed.

Today, just as Jesus was lifted up on the cross, we now look to Him for healing.

A sign of God's presence and love (Song of Songs 2:4).

satan and Banners: Did you know satan sets up his own banners?
"Thine enemies roar in the midst of thy congregations; they set up their ensigns (banners) for signs (of victory)" (Psalm 74:4, KJV).

We should be very liberal in setting up banners on our church walls and wave flags in the sanctuary of God; proclaiming His awesomeness, His power, and His authority as well as, to bring praise, glory and honor to the Name that is above all names, JESUS! After all, it is His house and He is worthy of it all!

The Calling to Raise a Standard:
Those who walk in obedience and in the anointing of God, and who raise a standard or banner in the Name of Jesus, cause the enemy to flee at the sight of it. You are a representative and ambassador of Christ – you carry Christ's authority.

Your hand represents healing, deliverance, miracles, power and strength. Moses is a great example of miraculous signs and the use of his hands.

In Exodus 4:2, God spoke to Moses and asked him, "What is that in your hand?" He replied, "A staff" (standard). He was told to throw it to the ground and it became a snake. By faith Moses picked up the snake which then returned back into a staff. God then told him to put his hand in his pocket. He took it out and it was leprous. Then, through obedience, he put his hand back in his pocket and it returned to normal.

In Exodus 4:17, God told Moses to take the staff in his hand so he could perform miracles with it. A typical shepherd's staff

became the rod of God in the hands of Moses! So, as we walk in obedience to God and obey His instructions, we raise a standard (rod) in Jesus' name, and by faith believe that God can and will use us to perform miracles, signs and wonders with it.

The standard of God is more than just a piece of wood; the anointing flows from the Holy Spirit through the person ministering with the standard and releases God's presence, power, healing and breaker anointing in the spirit realm. It is God who anoints for there is no anointing in the wood itself, but is a representation of prophetic symbolism. There needs to be wisdom and careful understanding when ministering with flags as our enemy himself is very familiar with this territory.

Banners: (Used in processionals)
Procession: (Hebrew: *Halijkah*) – to march, a company
Banners were used in processionals to usher in the presence of the Lord. When the Israelites walked through the wilderness and carried their banners, they were proclaiming, "Their God, the King of kings" is marching in the land. They marched together, unified, under leadership and authority. They had the same mission, to get to the Promised Land!

Processions are powerful. The world needs to see us, the church of Jesus Christ, marching together in unity, all races and denominations worshipping the same Lord, professing that there is but one God, and He alone is the Savior of the world!

David writes in Psalm 68:24-25, *²⁴Your procession, God, has come into view, the procession of my God and King into the sanctuary. ²⁵In front are the singers, after them the musicians; with them are the young women playing the timbrels.* This was a prophetic vision of God's processional into the sanctuary. In verse 25, he writes the order of the processional and what each person is doing.

Jesus is our Living Banner and the Rod of Jesse. When Christ

was crucified on the wooden cross, it was symbolic of Him being this living banner. Jesus said, "But when I am lifted up from the earth, I will draw all men to myself" (John 12:32). When we look to this banner, Jesus is the focal point, the rallying point. Jesus also declared, "Just as Moses lifted up the snake in the desert, so the Son of Man must be lifted up, that everyone who believes in Him may have eternal life" (John 2:14-15, NIV). This is a banner of salvation.

Chinese Silk Fans are used to "winnow:" Hebrew: *Zara* – To scatter, to spread out and throw away from. Read Jeremiah 15:5-7. This text is speaking on the righteous anger and judgment of God to the Israelites. Because Israel had disobeyed and forsaken their God, God would throw away and scatter His people from Himself. They were considered "enemies" of God.

Fans are used in the arts as a weapon of spiritual warfare. As we take the fans and start to move them, prophetically, we "winnow" or "fan" away the enemy from our presence. They can be used to create a beautiful snapshot in the minds of those who are watching, but the dancer must understand his/her movement and the true meaning behind it. The "thrusting away" of the enemy prepares the atmosphere spiritually for the Word to be delivered and the power of God to be released in the service.

Billows are used in the same context except billowing is a "rising, springing up and releasing" in a "wave-like" motion. When using billows in choreography, the minister needs to understand his/her movement; We "lift up" the glory and presence of the Lord and "push out" by the Spirit of God, releasing His presence over the people. (Isaiah 33:10). Those who are called to billow should be Intercessors.

In conclusion, lifting up a flag, streamer or banner by no means makes us a worshipper. We become worshippers of God by

experiencing true relationship and intimacy with Him. This will require personal quality time alone with Him. Without the spiritual connection and intimacy, we are just merely waving material in the flesh.

We should never put limitations on our giftings, and callings. In other words, we need to be ready and equipped in all areas of the arts. If God chooses to open His war chest and is in need of people to bring deliverance to someone by using a tambourine, we need to be trained and ready when called upon. If God chooses to use the dance and flags, then we need to be prepared for action. We should never limit ourselves to just "one" calling (just dance, etc.). We are the army of God, who can flow with diversity, trained and skilled in all areas of the arts when called upon to get the job done.

I would like to also address the mindset of dance being superior over all other forms of the arts. By no means is this correct. Flags, banners and streamers bring the "dance" up to the next level of worship and warfare. If you are not dancing, but carrying a banner or flag in a processional, my prayer is through this teaching you now have a better understanding of the importance of using all forms of the arts. There is not one greater than another in the giftings. Some will be gifted in one area more than another, but we are all equal in the eyes of the Lord. Please keep this principle in perspective, and you will never minister in error.

God intends for the arts to be used in a powerful way, **His way**, to bring salvation, healing, deliverance and liberty to all who are in captivity. So, let's lift up our banners and flags in the name of Jesus. Let us exalt Him and take the authority God has given to us, to decree and declare how great our God is! We declare: "The Lord is my Banner and Victor!" There is authority in His Name that I can execute at any time! The Rod of God is in my hands! We will lift up our banners and rods and exalt the Lord

Almighty! God has given us power as we extend our hands to separate the waters and do miracles!

Meaning of Colors

This is not an exhaustive study on colors, but a list of what you will need to know for general knowledge:

RED: Blood of Jesus, Atonement, Love, Power, Warfare and Salvation (Isaiah 1:18; Joshua 2:18, 21; Hebrews 9:12-14).

GREEN: Healing, New Life or Beginnings, Prosperity, Restoration (Revelation 22:2; Jeremiah 17:8; Psalm 23:2; Psalm 52:8).

BLUE: Reveals God, Priesthood, Seated with the Lord in Heavenly Places, Holy Spirit, Heaven, River of God (Revelation 22:1; Exodus 24:9-10; Ezekiel 1:26).

PURPLE: Royalty, Kingship, Wealth, Majesty, Priestly (John 19:2; Exodus 28:8; Judges 8:26).

GOLD: Glory, Godhead, Deity, Purification, Mercy Seat, Righteousness (Exodus 37:6; Revelation 1:13-14).

SILVER: Redemption, Wisdom, Purity, The Word of God (Proverbs 2:1-5; Genesis 44:1-9; Numbers 18:15-16).

ROSE PINK: The Father's Love Over Us as the Bride, Messiah, Rose of Sharon (Song of Songs 2:1).

WHITE: Purity, Holiness, Surrender, Light, Angels, the Saints, Peace, Victory (Isaiah 1:18; Ezekiel 1:4; Psalm 51:7; Revelation 3:4).

IRIDESCENT/CRYSTAL: Cleaning work of the Holy Spirit, Angelic Mantle (Ezekiel 1:22).

RAINBOW: Covenant Relationship, Glory of the Lord (Genesis 9:13; Ezekiel 1:28)

ORANGE: Passion, Power, Fire, Joy

YELLOW: Light, Joy, Celebration.

OUR STRATEGY:
When the people of God gather in His Name, He is in the midst (Matthew 18:20) The prayers of two people in agreement put ten thousand to flight (deuteronomy 32:30)

Putting on the whole armor of God….and having done all to stand. (Ephesians 6:13)

Submit yourselves to God and resist the devil and he will flee (James 4:7).

Praise Him! Worship Him! Pray without ceasing! Intercede on behalf of others! Walk in extreme obedience to the Word of God that brings us the victory!

The Ministry of Pantomime/Mime

I will make your tongue stick to the roof of your mouth
so that you will be silent and unable to rebuke them...
EZEKIEL 3: 26

Pantomime is the art of acting without words that silently displays life situations and messages from God's heart. It focuses on expression in character portrayal and is a merger of drama and dance.

A person who specializes in pantomime is called a mime. Some may ask the question if mime or pantomime is scriptural? The answer to that question is yes. The Lord used some of the prophets, in the old testament, to act out prophetic visuals to a rebellious, stubborn people as a way to get their attention to listen and repent. Ezekiel chapters 3, 4, 5, 12 and 21 all include examples of pantomiming as well as Jeremiah 13: 1-11, 18: 1-6, 19: 1-11, 51: 59-64.

Pantomime is a ministry and is birthed out of dance. The difference between dance and pantomime is that pantomime is extremely overly dramatic in movement. The movement of any part of your body to help express an idea or an emotion is called a gesture. There are two types of gestures: facial expressions and hand and arm movements. Here are just a few examples that

you can practice with each other on the dance team or in front of the mirror. These are facial expressions linked together with an idea or emotion:

Idea or emotion: Surprise
Facial expression: Eyes widen, brows lift, and mouth opens into a big O.

Idea or emotion: Happiness
Facial expression: Eyes squint, brows lift, the mouth curves up, sometimes with lips parting.

Idea or emotion: Sadness
Facial expression: Eyes narrow and lids drop, outer brow turns downward, mouth turns down, facial muscles sag.

Idea or emotion: Anger
Facial expression: Eyes narrow considerably, brows furrow, mouth twists downward, lips sometimes curl out and down in to a sneer, jaw drops and sets firmly.

Good facial expressions take practice. Pay attention how your face feels when you make certain expressions. Practice your expressions by looking in a mirror, and always remember your expressions need to be overly dramatic.

Just as a minister of dance is called by God, so should the person be to minister in pantomime. They need to be able to communicate God's ideas, thoughts and emotions without the use of words. He/she MUST have the ability to bring forth clear and precise expression. What is expression? It is a portrayal of what is going on inside of the person or to bring or force out from the inside. There are some who flow more "naturally" in expression due to their personality, BUT, personality should never limit someone from answering the call to ministry. Moses had stammering lips yet God still called him to lead a nation (Exodus 4:10). There are those God has naturally gifted in

expression, and will not have to work as hard to be an effective mime, just like in the dance. Some are just naturally gifted in movement where others have to work with greater effort to get certain dance steps.

What Makes a Good Mime

Individuality: A persons' character, personality and anointing on the gift.

Expression: Your facial expressions cannot be hindered or restricted at any time in your movement. I call this "undignified" movement, moving in total abandonment of self. Your movements are required to be BIG and HUGE! Sometimes you may feel ridiculous in portraying these monstrous movements, but if you are ministering on a stage far away, your large movements actually appear to look normal.

Anointing: A "must have" in this or any ministry for effectiveness. We must also keep in mind that expression does not necessarily indicate anointing. The same protocol and standards of dance should also be applied in the ministry of pantomime. The two ministries run parallel with one another.

A tragic mistake I have seen over the years in the arts are those who go up front to minister in pantomime and have absolutely no expression on their faces. It's absolutely grueling to have to sit and watch God's people "faceless" and "go through the motions". I call this spiritual robbery. Those who minister this way are literally robbing God of what is to be expressed from deep within His heart. We do not serve an emotionless God, in fact, it is quite the opposite. Jesus expressed many different emotions as He walked this earth. He wept, rejoiced, was grieved and even experienced disappointment at times. These are just a few to name. It was because of love, zeal and passion that the Father sent Jesus to die for us. We have a responsibility

to deliver messages from the heart of God that express His emotions through our movements. How can we tell people that our God is so awesome and powerful without it shining forth from our faces? We should be so impregnated with the anointing and glory of God that when we start to dance and bring forth His message that our inner man just explodes and radiates this glory. Remember dear Warriors, we are birthing things in to the atmosphere through our movements! When a baby is born, there is a great emotion of joy that takes place. Let's be like mirrors in heaven and reflect the face and glory of God to those around us and not portray Him as an angry, boring, disappointed, unhappy God. Unless you are pantomiming or doing a dance that is portraying anger, sadness or sorrow, your face should radiate with joy and gladness.

In my former dance ministry smiling was a prerequisite for dancing at the altars. No smile, no dance! How I trained my little Mustard Seeds (the younger children) on the team to smile was this: I would keep a small jar of vaseline on the back shelf of our arts room and tell them if they did not smile that I was going to put it on their teeth which would force them to smile. (This is what they do for Miss America pageants). The children always believed me when I would tell them this and they would get scared and say, "Oh no Sister Karen, I promise to smile!" I would always turn away and chuckle to myself knowing that I would never do it, but just wanted them to realize how important smiling is to God and how important it is to represent God correctly.

Leave all your cares and concerns outside the church doors the day you minister and refocus your mind on God. What a privilege and honor it is to be an ambassador for Christ!

Purpose of Mime Ministry

1. To deliver a clear message from God to the people
2. Prepares the way for the pastor to preach the Word
3. To lead the congregation into God's presence
4. To heal, save, encourage, deliver and set free those who are in captivity
5. To set the atmosphere of the service for the Holy Spirit to move and have His way

Purpose for White Face and Gloves

Painting your face white and wearing the white gloves are to highlight and accentuate facial and hand expressions emphasizing hands and face for proper interpretation. Black garments are worn to disguise the body so the face and hands can be the focal point. Be sure when painting your face that the lines around your face, hair and jaw line, is straight and smooth. Be sure to accent your mouth and eyes more to draw attention to those areas. Once your white face is on, it is no longer you behind that mask. The mask is used to portray many faces: you become anyone you want: a child, adult, a drunk, a man, a woman, a demon etc. You should never feel "comfortable" in your movements, as every move should be "bigger than life". You will need to be in good physical condition as it takes a lot of energy and cardiovascular endurance to minister in mime. (See Chapter 8 for conditioning the body).

How to Develop a Pantomime

1. After God gives you a song to minister to, practice the prophetic soaking technique in chapter 3, to get your movement. Not all songs are "mime" songs. Mime songs are usually songs that tell a story. Visualize the appearance

and emotional state of your character in minute detail. Decide how you will start your pantomime: is your head down, looking straight? Are your arms down, hands folded in front? Where will your entrance point be, from the back, side or in front? Are you holding any props?

2. Set your mental image in detail. Know exactly how much space you will be using and be sure to place any props that you will be using in its proper place.

3. Remember that in all dramatic work, the thought comes first; think, see, and feel it before you move. Let your eyes respond first to the emotion, then your face and head, your chest, and finally, the rest of your body. This is called a motivated sequence.

4. Always keep your actions simple and clear. Remember that pantomime should not be a guessing game where people are sitting and watching, trying to figure out what you are doing.

5. Keep every movement and expression "visible" to those you are ministering to at all times. Keep your head up and resist looking down towards the floor. Making eye contact is powerful!

6. Never make a movement or gesture without a reason. Ask yourself, "Does this movement or gesture clarify who my character is, how he or she feels, or why he or she feels that way?"

7. Finally, rely on the power of the Holy Spirit to help you practice and analyze every movement and gesture until you are satisfied that it is effective and truly expresses your idea or feeling. Remember to keep Jesus as your focus and primary audience.

CHAPTER 7

Evangelism and the Arts

"...I am sending you to them to open their eyes and turn them from darkness to light, and from the power of Satan to God, so that they may receive forgiveness of sins and a place among those who are sanctified by faith in me."
ACTS 26:17-18

WOW! Can you hear the heart of Jesus from the above text? It sounds to me that we have a mission to fulfill and it's not an option! We are commanded and called by God to fulfill the Great Commission. What an honor and privilege to co-labor together with the power of the Holy Spirit to complete this mission while we're here on earth.

The heart of God is never intended for us as the church to simply live a "blessed" and "comfortable" lifestyle, but to come to a place of maturity where we truly love the Lord our God with all our heart, soul, mind and strength and love our neighbor as ourselves. (Mark 12:30)

We are all challenged as children of God to walk a Christ like life and demonstrate God's heart to those around us. What is God's heart? Well, there are many answers to that question but one of His biggest burdens is for lost souls. God just simply

loves people! In fact, so much that He died for all mankind. (John 3:16)

Laying a Foundation

While Jesus walked the earth, He demonstrated His love and passion for souls to His disciples. He did not just merely talk the talk of evangelism, but He walked the walk. He led and taught by example that anyone who would dare follow after Him must be willing to leave all and live a selfless life; a life devoted to others.

Jesus came to seek and save what was lost! (Luke 19:10) He came to set captives free! (Isaiah 61:1) He was a friend of sinners! (Matthew 11:19) Jesus loved the unlovable, and those who were considered to be an outcast in society. He was a people person; not distant nor stand offish in any way but had enough compassion on those who were sick in their body to reach out to touch and heal even the worst of diseases (leprosy). He welcomed and embraced prostitutes, tax collectors and would weep over lost cities. Jesus even stood strong in the face of the religious leaders who falsely accused Him of being a drunkard and a glutton simply because of His association with the sinners. (Luke 7:34) He brought to life His Father's kingdom and heart here on earth but the question is, will we embrace it and follow after Him?

"...he that winneth souls is wise."
PROVERBS 11:30

We as the modern day church must examine our hearts and ask ourselves some very important questions when it comes to evangelism:

1. Do I possess God's heart to see the lost saved?

2. Do I even care about those who are going to hell? (family members, co-workers, friends etc.)

3. What am I willing to do to see them come to Christ? (do I pray, fast, spend quality time with them, pass out tracks etc.?)

4. Am I willing to lay my agenda aside to "associate" with the lost? If so, how? (do I develop a strategy?)

5. Am I willing to sow monetary seeds of love to local and foreign missions so the lost can hear the gospel preached?

These are just some basic questions that we need to ask ourselves from time to time to make sure our hearts and lives are properly aligned with the Father. If you struggle with answering some of these questions ask the Lord to help you "see" and "love" people the way He does. God saved us so we can tell others of His great love for them. Aren't you glad someone told you about Jesus?

Since we are living in the Last Days and the love of most has waxed cold (Matthew 24:12) now is the time, for the church, to arise and shine and allow the light of Christ to pierce the darkness! (Isaiah 60:1) God's light and glory overthrows powers of darkness and principalities. The light also breaks chains and strongholds and delivers those who are being held captive by satan. God's light brings authority and victory over the kingdom of darkness. Jesus is the Light of the world and because He lives within us, His light exposes the deeds of darkness, which then allows us to intercede on behalf of lost souls. We must tell others! It is urgent in this hour that we do all we can to bring as many people as possible in to eternity with us.

Arise and shine Oh sleeping Giant! Awake from your sleep and slumber as the night is quickly approaching when no man can work but while it is day, we must work! (John 9:4)

CREATIVITY, EVANGELISM AND THE ARTS

If I were to ask you to close your eyes and tell me what is the very first thing that comes to your mind if I say the word cat, what would it be? Majority of people would respond with the answer of them seeing a cat or a picture pertaining to a cat in their minds. I can guarantee that the letters C. A. T. did not scan across their eye gate. They most likely "saw" a picture of a cat. The reason why the arts is such an effective tool to touch people's hearts is because we were created to be "visual" people. God has made us in His image; we possess His spiritual DNA and because He is a creative God then so are we. (Genesis 1:1 - In the beginning God created the heavens and the earth…)

Jesus made a statement that He could only do what He saw His Father doing. (John 5:19) He saw it first in heaven then activated what He saw here on earth. God has painted many visual pictures in the Bible through visions, dreams, prophecies and parables because He understands how we are knitted together. Speaking through "visuals" can brand into our minds the truths of God; We do not always remember what we hear but by bringing in the arts to assist in sermons and for evangelism purposes, the pictures being painted is like a snapshot being taken in someone's mind. We do not just hear the message, but we can "see" the message. The power in the visual can bring instant recall in someone's mind at any time. For example, it amazes me sometimes when I hear an old song from the past how quickly it can take me back to a certain place and time where I can see and recall the memories in my mind like it just happened.

To all my warrior brothers and sisters, how awesome is it that God would call us for such a time as this to be used by Him as priests and ministers to bring forth His mighty Word through visuals! Let us do our very best to take the time to seek His kingdom in our ministries and be open to having the Creator God (Elohim) release new dances, movement and dramas to touch the heart

of every person watching. We daily need fresh manna (bread). Let us not be satisfied with eating stale bread; in duplicating one another's movements and doing things repetitiously, but press in to "see what the Father is doing" and then do it!

May each ministry team flow in their "uniqueness" to the glory of God as the Master Choreographer releases His anointing to change lives!

ARTS WITHIN THE CHURCH VERSUS OUTSIDE THE CHURCH WALLS

Have you ever stopped to ponder why our pews in the American church are filled with what I call "recycled Christians" and why we're not seeing the masses of lost souls enter through the church doors? Could it possibly be that we have left our spiritual roots (the early church in the book of Acts) to pursue our own man made ideas and methods of evangelism?

As we study the New Testament and the life of Jesus and His Apostles, we can clearly see that majority of the preaching, teaching and healing, took place outside of the church walls. God never intended for us to stay in our "four wall spiritual cocoons" to just sit and pray for the lost to come through our doors. No, God wants to activate us to go out and compel them to come in. (Luke 14:23, Matthew 22:9) Since the harvest is outside of the church walls, the church must realign herself to the very Word of God and return back to her spiritual foundation in reaching the lost in where the power of God was demonstrated through miracles, signs and wonders. We must rely on the power of God and not man's strategies and ideas, as good as they may be, yet bring the same Gospel message preached 2,000 years ago to our modern day society. I believe this is where the arts can be used as a vital tool or "bait" to catch fish!

Let's Go Fishing!

Flags, banners and different instruments of war can be used to "rally" people together from a distance and bring them to the area of where the arts team will be ministering. Once you grab their attention, you then have the opportunity to minister the Word of God to them through movement. An arts team that endeavors to move in this area of evangelism must seriously prepare themselves for a front line warfare ministry: (this is not an exhaustive list)

1. There should be spiritual mapping and scouting out land on where God would have you minister.
2. Fasting and prayer is a must!
3. Consecrate yourself unto the Lord and shut every door to the enemy. (holiness)
4. Working together as a team (unity) is MANDATORY! No exceptions!
5. Stay focused while in the enemies camp-do not allow any distractions to hinder your work
6. You must be willing to take persecution and be willing to die for the cause of Christ
7. Trust and believe that miracles, signs and wonders will follow you
8. Be baptized and filled with the Spirit

You MUST operate in all 8 things to be effective and successful. There are no shortcuts. I led a dance ministry of 35 people but I designed an "outreach" team of 15 that I knew could handle the streets, and were strong enough to align themselves with the 8 things above. Not everyone on your team may be spiritually mature enough to handle the battlefield so it is very important that if you are not chosen to be on the outreach team, please do not be offended as your leader's job is to discern who should be part of it. Your leader is simply covering you. Sometimes parents who didn't understand the ministry would fuss about it

and felt like I was playing favorites, but that was not the case at all. When I started to run in to this problem that is when I made it mandatory for parents to sit in on this training course so they would know exactly what the ministry was all about.

There is a place for the arts within the church as well. God is once again restoring His temple with praise and worship and it is usually during this time that the Holy Spirit begins to move upon people's hearts. It is necessary to reach those who are in the house of God who may not know Jesus and those who need a touch from Him but let's not just confine ourselves to only within the four walls. I believe the church has erred greatly in this type of thinking.

My prayer is that Pastors would release their arts ministries to do the work of the evangelist; Then God's house shall be full! (Matthew 22:10)

DIFFERENT FORMS OF EVANGELISM

1. PRAYER EVANGELISM: (location: outside)
This is a form of evangelism that takes place corporately as the body of Christ. There is merging of different church denominations to do prayer walks, prayer fairs and spiritual mapping together. By doing this type of evangelism brings the church community together, working in unity to take neighborhoods and cities. Denominational walls are shattered and as the body of Christ works together, a paradigm shift takes place and the power of God gets released to win the multitudes! This is what I believe to be the most powerful way to evangelize. It is God's heart; it is the book of Acts coming to life!

MUCH FASTING AND PRAYER WOULD BE REQUIRED TO OPERATE IN THIS FORM OF EVANGELISM DUE TO THE SPIRITUAL WARFARE INVOLVED. After laying the

spiritual groundwork, the arts ministries can be used on street corners, outdoor concerts, fairs, tent revivals etc.

Another very effective way to evangelize is in the marketplace. An example on how to easily witness to someone is in restaurants. Simply ask your waiter his name when you place your order and tell him that you always pray before eating your dinner. Tell him/her that you would like to include them in that prayer and ask if he has anything specifically he wants prayer for. You will be very surprised the reactions you get; you will make new friends along life's pathway. It opens doors to share your testimony and share the gospel. People are deeply touched by you taking the time to pray for their needs. Try It!!

Recommended reading material: *Prayer Evangelism* by Ed Silvoso
Recommended DVDs: *"FURIOUS LOVE"* and *"FINGER OF GOD"* by Darren Wilson. These are life changing videos and a MUST SEE for todays evangelism

2. PROPHETIC EVANGELISM: (location: outside)
This form of evangelism is "out the box" evangelism and should only be used by those who flow prophetically. You would set up tables in the marketplace to do "spiritual readings", dream interpretations and anything else that would attract people who are in to the New Age movement, witchcraft and the occult. You would be operating under the power of the Holy Spirit as oppose to the kingdom of darkness. Your goal is to witness to these types of people and win them for Christ as they are the potential "seers and prophets" for the church. MUCH PRAYER AND FASTING WOULD BE REQUIRED FOR THIS TYPE OF EVANGELISM DUE TO THE INTENSITY OF SPIRITUAL WARFARE.

Recommended reading material: *"Light Belongs in the*

Darkness" by Patricia King and *Dream Dreams* training course by Steve and Dianne Bydeley

3. FRIENDSHIP EVANGELISM: (LOCATION: OUTSIDE THE CHURCH)

This is where you establish friendships with co-workers, neighbors, and friends from the past and present to win them to Christ. I literally have seen tremendous church growth by using this method. Having fellowship and game nights with unsaved people to develop a trust and friendship is a very non-threatening way to see people come to Christ. You just need to connect!

After developing a relationship, invite them to come to your church service where they will hear the Word preached and see the Word come to life through the arts team.

Recommended reading material: *"Friendship Evangelism by the Book"* by Tom Stebbins

4. CONFRONTATIONAL EVANGELISM: (LOCATION: OUTSIDE)

This is where people hand out tracks, stand on street corners to preach the Gospel, go into public places like super markets, parks, fairs etc. to minister in music and dance. This method is more of an *"in your face"* approach, but does not mean that it is cold or harsh. Anytime we are presenting the Gospel it must be done with the love of Christ and in the right attitude. The world will sense if we are not operating in love and have underlying motives. We should never be out promoting our church, but only Jesus Christ crucified and His resurrection! The cross and resurrection power should always be our focus and motivation not joining a specific church. Yes, they will need a place to go to be trained up after they get saved, but we don't want people to think we are promoting only our church, but simply a love relationship with Jesus.

The arts ministry can be used very powerfully in this form of

evangelism; you can walk down streets in neighborhoods and look for people to minister to. Going to parks, street corners, subways, and train stations etc. are great places to minister in the arts. The evangelism should be led by the Holy Spirit.

You have approximately 3 minutes to win a complete stranger to Christ (i.e.: waitresses, sitting next to someone riding on a train or bus) which will require some skill when evangelizing. Share your testimony of how you got saved whenever you have the chance. People may argue doctrine or the Word of God but they cannot argue with your testimony and how God has changed your life.

THE ART AND SKILL OF EVANGELIZING: IT'S ALL ABOUT PERSUADING

Here are just a few tips when sharing the Gospel:

1. Be friendly, smile and always introduce yourself. Make yourself approachable.
2. Do not speak "Christianese" to them. (Words like saved or born again-say a brand new life)
3. Make direct eye contact and speak with authority. When speaking, be enthusiastic in delivering your message. People will gravitate to your passion; you want them to catch it!
4. A great opening statement to approach someone would be, "Did you know that God loves you and has awesome plans for your life?"
5. Share with confidence your testimony of how you came to Christ.
6. Have faith and believe that the power of the Holy Spirit will flow through you so you can testify to the resurrection of Christ and His soon return.
7. Bring a message of repentance and reconciliation. Make

them understand that they are separated from God and stand condemned without the blood of Jesus.

8. Share the Good News and how He provided a way of escape from death through the cross.

9. Ask if they would like to receive the free gift of eternal life. If not, do not force it. Some plant, some water but God causes it to grow.

10. If they do want to receive salvation, pray a SIMPLE prayer: (ABC's)

(A) Ask Christ to come into their heart.

(B) Believe on the name of Jesus Christ and they will be given a new life

(C) Confess their sins and receive forgiveness.

**If they do not accept salvation ask them if you can quickly speak a blessing (pray) over them. Something as simple as: Lord Jesus, I thank you for allowing me to meet_____ today. I ask that you would protect _____and let him/ her know that You are God, and that You are real. Help _____to know that You love him/her and stand with open arms at any time to receive him/her just as he/she is. I bless you _____in the mighty Name of Jesus, Amen

Thank them for their time.

MINSTERS OF THE ARTS: Your calling is not to just visually share the Gospel through movement, but you are obligated to open up your mouths to speak with boldness when the opportunity arises when out in the harvest field. Look for open doors and walk right through them, as missed opportunities leads to regret. Shake off any type of rejection as they are not rejecting you but Jesus.

UNTIL WE CATCH THE VISION FOR SOULS, WE ARE LIVING BENEATH OUR GOD-GIVEN POTENTIAL. OUR

PRIMARY MANDATE IN LIFE IS TO WIN AND DISCIPLE SOULS.

THERE ARE PLENTY OF FISH IN THE SEA. LET'S GO GET EM'!!

Conditioning the Body through Nutrition and Physical Training

Do you not know that your body is a temple of the Holy Spirit, who is in you, whom you have received from God? You are not your own; you were bought at a price. Therefore, honor God with your body.
(1 CORINTHIANS 6:19-20, NIV)

When it comes to the physical body and the ministry of dance, the one called by God will need to incorporate discipline in the area of eating and exercise habits, in order to move effectively in the dance. Conditioning and training the body is all part of becoming a strong warrior in God's army, much like when someone enlists in the US Army. From day 1, you have specific drills and disciplines that you must follow in order to become a successful soldier.

A CREATIVE WAY TO TRAIN AND CONDITION THE BODY

One may truly desire to minister and worship the Lord in the dance but will need to be physically capable to do so. We also need to train to prepare ourselves not just for ministry within the four walls of the church but also outside the walls for evangelistic

purposes. Most evangelistic outreaches are held in the summer, so there needs to be strict training for the physical body in order to endure the extreme hot temperatures. Here are some suggestions and techniques that I used with my dance ministry to help prepare for outdoor events: In the very beginning of springtime weather, start to take the team outside for practices to condition the body. Line the dance team up in pairs and side by side. If you are able to, jog around the church parking lot or the building you are meeting. Depending on how physically fit the dance team is, you may need to jog a little, then you walk. As a personal trainer, I usually start someone out with a 10 to 15 step-walk and 20 to 30 jogs. This is called interval training and will help you and your team to go longer distances and at the same time safely develop their cardiovascular system. As you jog together, have each person 1 by 1 yell out a scripture they have memorized and have the rest of the team repeat it back; much like a cadence.

Here is an example:
1) First person yells; "Proverbs 3: 5 and 6" then the team repeats it.
2) Same person yells: "Trust in the Lord with all your heart", then team repeats.
3) "And lean not on your own understanding", team repeats.
4) "In all your ways acknowledge Him", team repeats
5) "And He will direct your paths straight", team repeats.
6) "Proverbs 3", repeat
7) "5 & 6", repeat
8) "Proverbs 3:5&6", repeat.

Have the second person pick his/her favorite scripture and do the same cadence as above until everyone has had a chance to lead. It's a fun way to challenge the team to know God's Word and at the same time condition the physical body.

Because the Lord gave me a large children's dance ministry,

and I was off all summer due to my job, I ran a program that I called a "Witness, Fitness Dance Camp". In the morning, we would start off in the park doing exercise drills, playing running games, jump rope competition and obstacle course races then moved in to a time of the Word. We then had a picnic and a time of fellowship together and would end our day by practicing our dances in the park, asking people if we could minister to them. At the end of our dance we would pray and talk with them about the love of Jesus. This was a fun way to evangelize and prepare the teams' body to be exposed to the extreme heat. A great way to train during the cooler months is to have each dance team member purchase a mini rebounder (trampoline) for themselves, bring it in for practice and take turns leading in exercise movements. A 6 minute aggressive work out doing high knee raises and kicks is equivalent to running one mile, so you won't have to do it long. You can go online to purchase a DVD for different methods of exercise on your rebounder. You can also purchase your rebounder at a very reasonable price at a DICKS Sports store nearest you. If you would like more detailed information on the dance camp and the way it was conducted and the benefits of rebounding, please feel free to contact me at www.thedancingwarriorbride.com.

HOW TO CONDITION THE TEMPLE OF GOD
As a certified health minister through Hallelujah Acres, I want to emphasize that my focus for this teaching is not centered on addressing weight issues but more on health issues. By following the principles taught on the next few pages, it will help you lose some of those extra pounds you've longed to get off and create a healthy physical temple that will sustain you through your dances.

Please have an open mind, and take off the limitations that sometimes entangle us. These are guidelines – not rules. We are no longer under the Law but there are some very important

principals that God addresses in the Old Testament that can still be useful for us today. Let's go back and see what God had established from the very beginning of time about man's diet; a time when sin had not yet entered the heart of man and everything was in a perfect state of being. I call this plan A, God's perfect plan and will for mankind.

Genesis 1: 26 Then God said, "Let us make man in our image, in our likeness, and let them rule over the fish of the sea and the birds of the air, over the livestock, over all the earth, [b] and over all the creatures that move along the ground."
27 So God created man in his own image,
in the image of God he created him;
male and female he created them.

28 God blessed them and said to them, "Be fruitful and increase in number; fill the earth and subdue it. Rule over the fish of the sea and the birds of the air and over every living creature that moves on the ground."

29 Then God said, "I give you every seed-bearing plant on the face of the whole earth and every tree that has fruit with seed in it. They will be yours for food. 30 And to all the beasts of the earth and all the birds of the air and all the creatures that move on the ground—everything that has the breath of life in it—I give every green plant for food." And it was so.

After God had created the heavens and the earth and everything in the earth (including man), in verse 29 and 30 God gave mankind and the creatures of this earth their diet; fruits vegetables, seeds and nuts. When God released this diet, there was no sin present; it was His perfect will in a perfect world for ALL creation to live on a vegetarian diet. There was no killing or bloodshed of animals for meat, just pure raw foods for the strengthening and nourishment of the body. God knew exactly what He was doing by giving mankind this type of diet as all the nutrients, vitamins

and minerals as well as enzymes that the body would need to sustain long life is found in raw food. Even the wild animals would eat vegetation (every green plant) for food.

It wasn't until after sin came in to the world, and God regretting making mankind because of the evil intentions of their heart, (Genesis 6:5-6) that He would now allow animal flesh to be consumed in a vegetarian body. (Genesis 9) This was God's permissible will or plan B for mankind.

1 Corinthians 10:23, teaches believers that everything is permissible, but not everything is beneficial or constructive. We are free in Christ to eat whatever we wish, but the body of Christ lacks great wisdom when it comes to understanding how food affects the body. Most Pastors do not preach on the physical body, just the soul and spirit part of man but we are made up spirit, soul and body and because of the neglect in teaching wisdom in nourishing these precious temples that the Holy Spirit dwells in, believers die a premature death due to ignorance; a lack of knowledge. (My people perish for the lack of knowledge. Hosea 4:6) Eating a daily diet high in saturated fat, refined sugar and animal products will cause debilitating diseases in the body. The law of sowing and reaping is still in effect to us today, not just spiritually, but also naturally. America is one the wealthiest nations in the world yet we are one of the sickest; we eat like the kings and queens of old. Have you ever noticed in old history books when you see pictures of kings and queens sitting on their thrones that they are usually very round, full faced people and yet their servants are pictured very thin? The reason why is the servants would usually eat fruits and vegetables as their diet versus the kings and queens would eat from their wealth which included a lot of meat. Meat in Biblical times was 3% fat. Today it is anywhere between 20-60% fat. Cheese is 90% saturated fat and low fat cheese is 70%. No wonder America's #1 death is heart attacks and strokes

(1 out of 2 people) and cancer running a close second (1 out of 3). Over one-third of Americans are obese; it is because we are putting the wrong fuel in our gas tanks! Food is much like fuel; your body is the car or vehicle and the food you eat is the fuel. By putting the wrong octane of fuel (food) in your vehicle, it will eventually start to "ping and knock" and gradually stop performing to the capacity it was designed to function. It's the same with food; putting the wrong kind of fuel (food) in your body will cause you to become sluggish, tired, experience aches, pains and eventually can lead to diseases to manifest. All of these symptoms are the "pinging and knocking" going on in your vehicle. Now, some of you are thinking, "well, I pray over my food so God is blessing it" but is He really blessing it? If He was blessing our 60% saturated fat from pork and 20-40% fat from chicken, then why is the church just as sick as the world? Wouldn't we be "healthier" because God is blessing our food? No, Christians are just as sick as the world because we are eating the same diet as they are. We have conformed to the patterns of this world in many ways including eating the S.A.D. diet or the Standard American Diet. You reap what you sow; If you sow healthy living food that contains all the life force and nutrition your body was designed to partake of, then you will reap the healthy benefits and the blessings that God designed from the very beginning of time to your body. Life begets life; you cannot take something that is in a dead state (cooked) and create life out of it. For instance, when you cook your food, you destroy most or if not all the nutritional value in the food as well as the enzymes that your body needs to function on a healthy, daily basis. You cannot create a healthy living cell by eating dead, cooked food BUT you will create healthy living cells by eating living, raw foods. Once again, this is just a guideline to follow that I know will bless your life with quality and longevity by applying these principals.

MY TESTIMONY: At the age of 35, I was diagnosed with

rheumatoid arthritis in my back and my right knee. I was in constant pain and the doctors wanted to put me on steroids to treat the problem but I refused the medication and started to do some research on natural ways to heal the body. I went and had X-rays taken of my back and the doctor told me I had bones of an 85 year old. At that time I was exercising but I ate the standard American diet that consisted of a lot of meat and sugar. About 2 years later the Lord led me to Hallelujah Acres, a Christian health and nutrition retreat center and school, and I started to apply the 10 commandments of health that are listed below. I went on a strict vegan diet (no animal products), drank plenty of carrot and vegetable juices and within 6 weeks, all arthritis as well as every other ailment in my body was gone! One year later I went back to have my bones x-rayed and the doctor told me I had bones of a 15 year old! I was able to regenerate and rebuild my entire bone structure in my body simply by applying the Genesis 1:29 lifestyle, to my life. I am currently today more healthier and stronger than I was 10 years ago before I started the diet and am totally disease free in my body. It literally gave me my whole life back! So, I can testify to God's perfect will of eating raw fruits and vegetables, grains, seeds and nuts and the healing power that is in it. God literally renewed my youth like the eagle! (Psalms 103:5) I am not saying that I won't ever get sick but by applying God's perfect diet, I eliminate my chances of sickness and disease tremendously. Ultimately, I want to praise and worship my God for as long as I can as well as be a testimony to an unhealthy, sick dying world. I challenge you to try it, especially if you are dealing with any form of sickness in the body. The Bible says that we are fearfully and wonderfully made (Psalms 139:14) and that our bodies are the temple of the Holy Spirit; Let's consecrate our spirit, soul and physical body, keeping it holy (set apart) and blameless at the coming of our Lord Jesus Christ (1 Thess. 5:23)

For more information on the Hallelujah lifestyle and detoxifying

the body, please go to www.hacres.com. My husband and I have helped many people overcome cancer, arthritis, diabetes etc. by applying these principals. You may also contact me on my website, www.thedancingwarriorbride.com for a free consultation in regards to any health problems you may be suffering with. Ken and I have made it our personal life long goal to help as many people as possible to live the abundant life of Christ here on earth! If you have any questions in regards to purchasing their products, feel free to contact me at your convenience.

Below is what I call the 10 commandments of health. My prayer is that you will take the challenge to bring spiritual disciplines and alignment to the physical body so you can be a witness and testimony to others of how great our God is!

10 Commandments of Health

Dear friend, I pray that you may enjoy good health and that all may go well with you, even as your soul is getting along well. (3 John 2)

We can clearly see from this scripture that it is always God's will that His children walk in health and wellness. Here are some practical ways to remain in good health:

1. Nutrition: Eat 75-85 percent raw food (fruits, vegetables, seeds, nuts); 15-25 percent cooked. Include 2, 8 oz. glasses of fresh, raw juices. (I also teach on juice therapy and how the wonderful effects of drinking living vegetable juices daily affect the body. There are some very important keys you will need to know about juicing; you may visit my website or go to the www.hacres.com website for more information on juice therapy). Try to cut back or eliminate all animal products as much as possible. Keep the colon clean. (Eat

plenty of fiber throughout the day. You should be having 2 to 3 bowel movements a day. An excellent, powerful colon cleanser by Hallelujah Acres is herbal Fibercleanse.) A great book to read by Hallelujah Acres is "God's Way to Ultimate Health". It is an easy to read book that gives you wisdom and understanding of how the body functions, how to safely detoxify the body, juice therapy, eliminating sickness and disease from the body as well as over 200 healing testimonials from different people all over the world. If you call to order any products, just give them my name and my pin number AFN, they will put me as your health minister for faster service, or visit my website to purchase health products at discounted prices.

2. Exercise: Cardiovascular (heart and lungs) --running, walking, jump rope, aerobics etc. 3-6 days a week, up to one hour. You need to work up to a good sweat, which will eliminate toxins from the body. Being in the ministry of dance is a great way to stay in cardiovascular shape.

 Stretching – every day. Being flexible is extremely important in dance ministry. Be sure to stretch all your major muscles and hold for 15 to 20 seconds.

 Strength training – 3-5 times a week. Lifting lightweights for toning will help keep muscles strong for longevity. Make sure you are also training your core muscles; abdominals and lower back. This helps you keep your body properly aligned with good form staying balanced and centered in your movements.

3. Water: How much water should you drink? Take your weight, divide in half and drink that many ounces per day. Drink distilled, purified or filtered water as much as possible. (Ex. If you are 150# you should be drinking approx. 75 ounces a

day of fresh water. Helps to cleanse and detoxify the body)
Never drink tap water due to high levels of chemicals.

4. Sunshine: 15-30 minutes a day before noon or after 3 pm.
It is imperative to get your hormone vitamin D from the
sunshine as you need vitamin D to absorb calcium in the
body. In most cases, people who have cancer are vitamin D
deficient. African Americans need six times more sunlight
exposure than Caucasians for proper vitamin D absorption.
Sunshine also relieves stress from the body keeping the
immune system strong.

5. Temperance: Avoid harmful substances as much as possible
such as tobacco, drugs, prescription drugs, excessive alcohol
etc.

6. Attitude of Gratitude: 1 Thessalonians. 5:18 says that we
should give thanks in all things, as this is God's will for us.
Be thankful even in the hard times as God has made this
promise to His children: *"And I am sure of this, that he who
began a good work in you will bring it to completion at the
day of Jesus Christ."* Philippians 1:6. So no matter what may
come your way in life, you can rest assure that God is in full
control and will work everything out for His good and glory.
Sometimes you may just need to encourage yourself in the
Lord by remembering and recalling all that God has done
for you in the past and then rely on the many promises He
holds for your future. Learn to release your heavy burdens
to Jesus, laying them down at the foot of the cross, then turn
away by faith knowing that God is working and has it all
under control.

7. Rest: Try to be asleep by 10 pm. Healing hormones are
released between the hours of 10 pm and 2 am. Rest allows
your physical body to heal and is a weapon against the
kingdom of darkness. Refrain from becoming too busy. If

you have a problem getting to sleep due to your mind racing of all the things you will need to do the next day, write down on a piece of paper your thoughts so you won't forget and have a peace of mind that your list will be there waiting for you upon arising.

8. Trust in God: No matter what you're going through, have faith in knowing God is with you and will be faithful to carry you through. In order to trust someone, you must first know who they are. Take the time to get to know God. He loves you and cares for you. Declare Proverbs 3:5&6 over your life: *"Trust in the LORD with all your heart and lean not on your own understanding; in all your ways acknowledge him, and he will make your paths straight."*

9. Read the Word: By feeding your physical man with good natural foods and your spiritual man good food by the Word of God, this brings in a perfect balance to living the abundant life Jesus said we can have. (John 10:10) God's Word brings peace and security in our every day lives and gives us the strength to face and overcome any obstacle that the day may bring.

10. Benevolence: Get outside yourself and do something for someone else. You never know that all the hard circumstances that you have had to endure throughout your life can be a blessing to someone that is now facing the same situation. Get rid of bitterness, anger and resentment. One big blowup with someone will suppress the immune system for seven hours.

WORKS CITED

BibleSoft. *PC Study Bible*. Formatted Electronic Database. BibleSoft, Inc., 2006. Brown, Elizabeth. "Weapons of Mass Destruction." Seminar, Lighthouse Tabernacle Assembly of God, Lumberton, NJ, Spring 2007.

_____. *Weapons of Mass Destruction*. Salt Lake City, UT: Aardvark Global Publishing Company, 2006.

Day, Lorraine. *You Can't Improve on God*, DVD. The Raw Food World, 2008.

Jusu, Hawa. "Mime." Lecture, Mime/Drama Workshop, Lighthouse Tabernacle Assembly of God, Lumberton, NJ, 2007.

Lightfoot, Karen. "Colors in the Bible." Lecture, Spirit of Excellence Beyond the Dance Training Course, Lighthouse Tabernacle Assembly of God, Lumberton, NJ, 2008.

_____. "A Deeper Understanding of Prophetic Dance." Lecture, Spirit of Excellence Beyond the Dance Training Course, Lighthouse Tabernacle Assembly of God, Lumberton, NJ, 2008.

_____. "Priestly Garments." Lecture, Spirit of Excellence Beyond the Dance Training Course, Lighthouse Tabernacle Assembly of God, Lumberton, NJ, 2008.

_____. "Soaking in the River." Lecture Spirit of Excellence Beyond the Dance Training Course, Lighthouse Tabernacle Assembly of God, Lumberton, NJ, 2008.

_____. "Spiritual Requirements for the Dancer." Lecture, Spirit of Excellence Beyond the Dance Training Course, Lighthouse Tabernacle Assembly of God, Lumberton, NJ, 2008.

_____. "Weapons of War." Lecture, Spirit of Excellence Beyond the Dance Training Course, Lighthouse Tabernacle Assembly of God, Lumberton, NJ, 2008.

Malkmus, George. *The Hallelujah Diet.* Shippensburg, PA: Destiny Image Publishers, 2006.

Niblack, Crystal. "The Ministry of Dance" Willingboro, NJ. Spring 2005

Schanker, Harry H. and Ommanney, Katharine Anne. "The Stage and The School": Glencoe/McGraw-Hill, 1999.

Strong, James. *The Exhaustive Concordance of the Bible.* 1894. 42ed ed. Nashville: Abingdon Press, 1983.
